Warhol

1928-1987

Grange
BOOKS

Page 6:
Self-Portrait, 1986
silkscreen and acrylic paint on canvas
101.6 x 101.6 cm
Private Collection

Designed by:
Baseline Co Ltd
19-25 Nguyen Hue
Bitexco Building, Floor 11
District 1, Ho Chi Minh City
Vietnam

ISBN 1-84013-737-1

Published in 2004 by Grange Books
an imprint of Grange Books Plc
The Grange Kingsnorth Industrial Estate
Hoo, nr Rochester, Kent ME3 9ND
www.grangebooks.co.uk

Printed in China by Everbest Printing Co Ltd

"I was getting paid for it, and did anything they told me to do. If they told me to draw a shoe, I'd do it, and if they told me to correct it I would – I'd do anything they told me to do, correct it and do it right... after all that "correction", those commercial drawings would have feelings, they would have a style. The attitude of those who hired me had feeling or something [near] to it; they knew what they wanted, they insisted; sometimes they got very emotional. The process of doing work in commercial art was machine-like, but the attitude had feeling to it."

– Andy Warhol

Andy Warhol

Biography

1928 : Andrew Warhola is born on the 6th August in Pittsburgh. His parents are of Czechoslovakian origin. His father arrived in the United States of America in 1913, and is reunited with his wife, in 1921, after being separated by the war.

1936-38 : Towards the age of 9 he is victim of a bout of madness and remains bed-ridden colouring pictures to pass his time.

1939 : He becomes fascinated by the radio and the stars of the music world.

1942 : Death of his father

1945 : Studies graphic design at the Carnegie Institute of Technology

1948 : He receives his B. F. A. from the Carnegie Institute of Technolgy, Pittsburgh and moves to New York with his friend Philip Pearlstein.

1949 : His first drawings appear in the review 'Glamour' followed by 'Vogue', 'The New Yorker', 'Harper's Bazaar' and the 'New York Times.' He starts to call himself Warhol.

1952 : He receives a prize for the best advertisement, awarded by the Art Directors Club.

1953 : First individual exhibition in the Hugo Gallery, New York.

1954 : Receives a certificate of excellence from the American Institute of Graphic Arts. Exhibition in the Loft Gallery, New York.

1956 : Further award. He designs shoes for the stars by a collage of gold leaf. Between the 16th June and the 12th August he tours the world.

1960 : Drawings of *Dick Tracey* and *Popeye*.

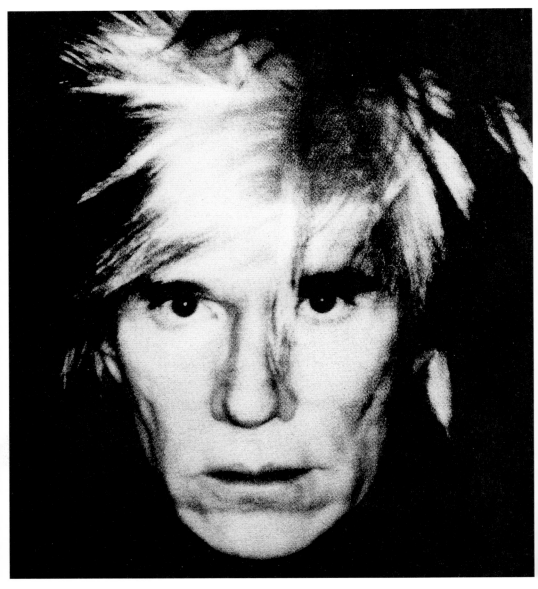

1961 : First paintings of 'Campbells soup cans' and 'Dollars' as well silkscreen prints which are consecrated to the American 'Superstars' (Marilyn Monroe, Elvis Presley, Marlon Brando, Nathalie Wood…)

1962 : Produces a series of disasters or dramatic events such as 'Car crash' or 'Electric Chair'. Warhol creates his 'Factory' where each member helps in the production of the works and certain assistants carry out a whole visual project of paintings from the sketches created by Warhol.

1963 : Meets Gérard Malanga. Mass silk printing and start of the film production on the underground (Sleep, Empire, Chelsea Girls)

1964 : Designs three-dimensonal fascimile Brillo boxes, Heinz and Del Monte tins.

1966 : Leo Castelli wants to make New York an international place for contemporary art and so buys some works from Warhol. Warhol shocks the contemporary art world by mixing art with business.

1968 : First exhibition in Europe in Stockholm. On the 3rd June, Valérie Solanis attempts to murder Warhol.

1969 : First edition of the review 'Interview' of which Warhol is co-editor and star journalist.

1972 : Produces portraits of 'Mao Tse-Tung.'

1977 : Warhol produces commissioned works.

1980 : Warhol evolves in his artistic expression. He realises his artistic limits and decides to collaborate with Jean-Michel Basquiat and Francesco Clemente.

1982 : Warhol sets up his own cable television channel called Andy Warhol TV.

1984 : Publication of the summary of Pop art, 'The Warhol 60s.'

1986 : Series inspired by Leonardo da Vinci's works such as 'The Joconde.'

1987 : 'Autoportraits'. Andy Warhol dies on the 22nd February.

Andy Warhol was an artist who undoubtedly put his finger on the pulse of modern culture. Through pioneering a variety of techniques, but principally by means of the visual isolation of imagery, its repetition and enforced similarity to printed images, and the use of garish colour to denote the visual garishness that is often encountered in mass culture, he threw much direct or indirect light upon modern *anomie* or world-weariness,

Golden Boy

1957
ink, pencil on heavy cardboard, 49.5 x 34.6 cm
Stiftung Sammlung Marx, Museum für Gegenwart, Berlin

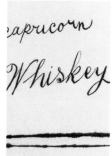

nihilism, materialism, political manipulation, economic exploitation, conspicuous consumption, media hero-worship, and the creation of artificially-induced needs and aspirations. Moreover, in his best paintings and prints he was a very fine creator of images, with a superb colour sense and a brilliant feel for the visual rhythm of a picture which resulted from his intense awareness of the pictorial potentialities inherent to forms. Initially, his images might appear rather simple.

Capricorn Sloe Whiskey Fizz

1959
draw by ink on paper, coloured with the hand
60.3 x 45.7 cm

capricorn

Aloe Whiskey Fizz

Juice of ½ lemon, 1 teaspoon sugar, 1 jigger whiskey. Shake with ice, strain into highball glass. Fill with soda and ice cubes.

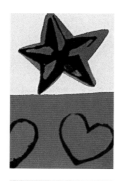

Yet because of that very simplicity they not only enjoy a high degree of immediate visual impact, but also possess the rare power of projecting huge implications through the mental associations they set in motion. For example, the visual repetitiousness that Warhol employed within a great many of his images was intended associatively to parallel the vast repetitiousness of images that is employed in a mass-culture in order to sell goods and services –

Horoscope pour l'heure du cocktail

1959
ink and watercolour on paper, 60.9 x 45.7 cm

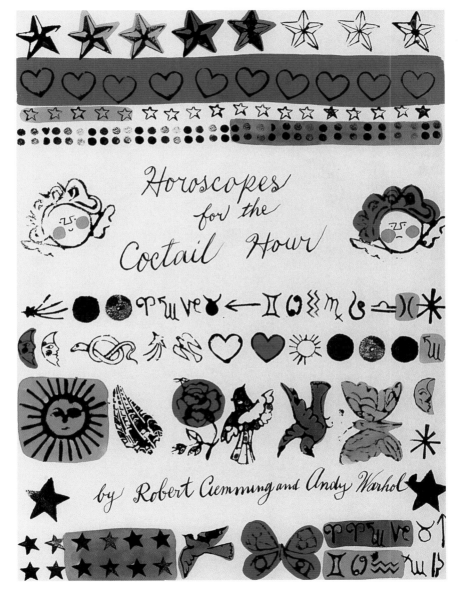

Horoscopes for the Coctail Hour

by Robert Clemming and Andy Warhol

including vehicles of communication such as movies and TV programmes – whilst by incorporating into his images the very techniques of mass production that are central to a modern industrial society, Warhol directly mirrored larger cultural uses and abuses, while emphasizing to the point of absurdity the complete detachment from emotional commitment that he saw everywhere around him.

Stars, Hearts, Butterflies,
Fruits and Birds

1959
ink and watercolour on paper, 73.6 x 58.4 cm

Moreover, as well as employing imagery derived from popular culture in order to offer a critique of contemporary society, Warhol also carried forward the assaults on art and bourgeois values that the Dadaists had earlier pioneered, so that by manipulating images and the public persona of the artist he became able to throw back in our faces the contradictions and superficialities of contemporary art and culture.

Where is your rupture?

1960
casein on canvas, 177.2 x 137.2 cm
Private Collection

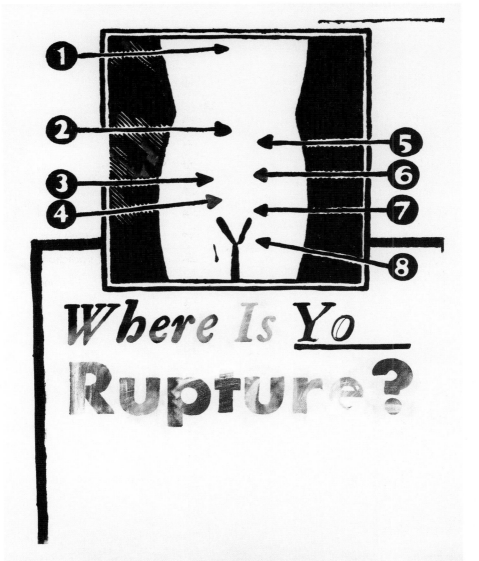

And ultimately it is the trenchancy of his cultural critique, as well as the vivaciousness with which he imbued it, that will surely lend his works their continuing relevance long after the particular objects he represented – such as Campbell's Soup Cans and Coca-Cola bottles – have perhaps become technologically outmoded, or the outstanding people he depicted, such as Marilyn Monroe, Elvis Presley and Mao Tse-Tung, have come to be regarded merely as the superstars of yesteryear.

Dick Tracy

———

1960
casein and pencil on canvas, 121.9 x 83.9 cm
The Brant Foundation, Greenwich

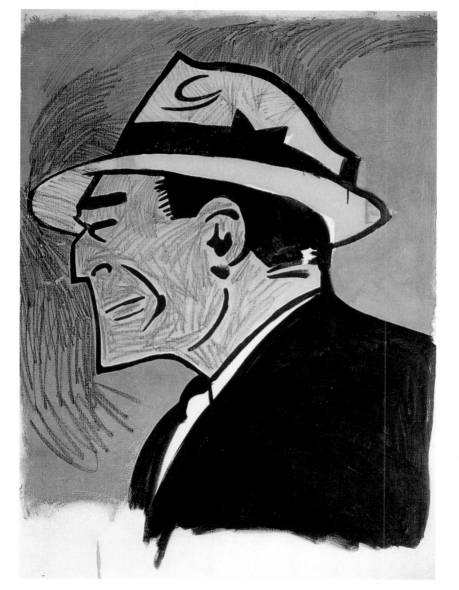

Andy Warhol was born Andrew Warhola on 6 August 1928 in Pittsburgh, Pennsylvania, the third son of Ondrej and Julia Warhola. They were immigrants from what is today the Slovak Republic but which was then part of the Austro-Hungarian Empire. After leaving school in 1945, Warhol attended the Carnegie Institute of Technology in Pittsburgh, majoring in Pictorial Design, where he received an excellently rounded art education.

Before and After

1961
casein and pencil on canvas, 137.8 x 175.3 cm
The Metropolitan Museum of Art, New York

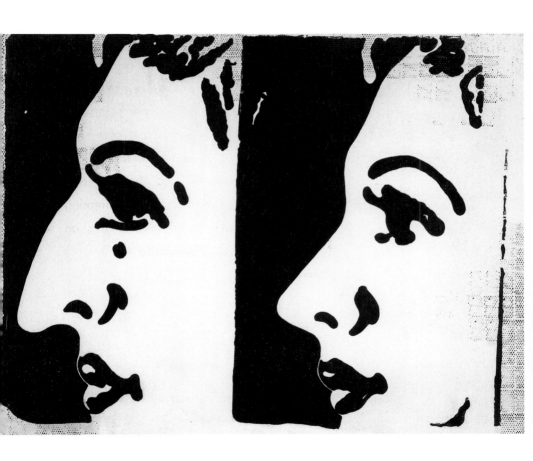

In the spring of 1948 Warhol obtained a degree of professional design practise by working part-time in the art department of the largest department store in Pittsburgh. In June 1949 he graduated from the Carnegie Institute with a Batchelor of Fine Arts degree. The following month he moved to New York where he soon made the acquaintance of Tina Fredericks, the art editor of *Glamour* fashion magazine. She commissioned a suite of shoe illustrations, shoes being a subject that Warhol would soon make his speciality.

Saturday's Popeye

1961
casein on canvas, 108 x 99 cm
Ludwig Forum für Internationale Kunst, Aachen

When these illustrations appeared in the magazine in September 1949, the 'a' in Warhol's surname was dropped from the credit byline (possibly by accident) and the artist adopted that spelling thereafter.

Warhol was determined to succeed in New York and he haunted the offices of art directors in search of work, even cultivating a down-and-out, 'raggedy Andy' look in order to gain the sympathy of potential clients.

Campbell's soup Can
(Turkey Noodle)

1962
silkscreen ink on canvas
Sonnabend collection

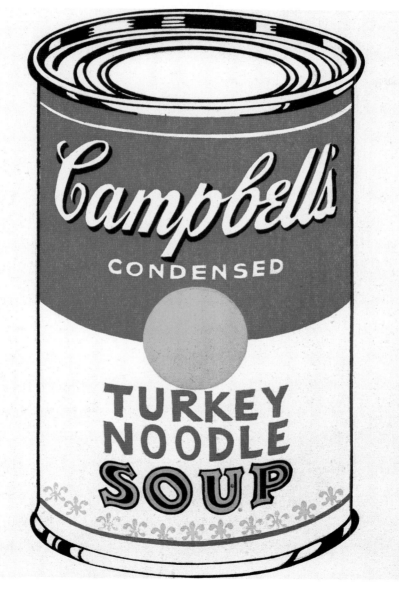

One successful commission soon led to another, and within a relatively short time Warhol was much in demand for his highly characterful illustrations, both within the Conté Nast organisation (to which *Glamour* magazine belonged) and beyond it. Warhol was extremely accommodating as far as all his employers were concerned, for as he related in 1963:

Green Coca Cola Bottles

1962
silkscreen ink, acrylic paint and pencil on canvas,
209.5 x 144.7 cm
Whitney museum of American Art, New York

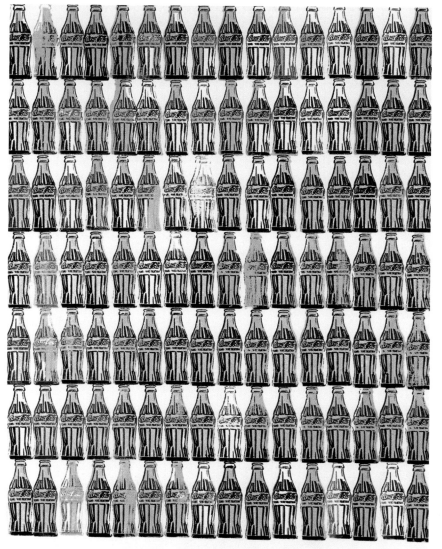

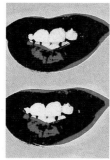

I was getting paid for it, and did anything they told me to do. If they told me to draw a shoe, I'd do it, and if they told me to correct it I would – I'd do anything they told me to do, correct it and do it right....after all that "correction", those commercial drawings would have feelings, they would have a style. The attitude of those who hired me had feeling or something [near] to it; they knew what they wanted, they insisted; sometimes they got very emotional. The process of doing work in commercial art was machine-like, but the attitude had feeling to it.

Marilyn Monroe's Lips

—————————————

1962
silkscreen ink on synthetic polymer paint and pencil on two canvases
210.2 x 209.2 and 210.2 x 205.1 cm
Smithsonian Institute, Washington DC

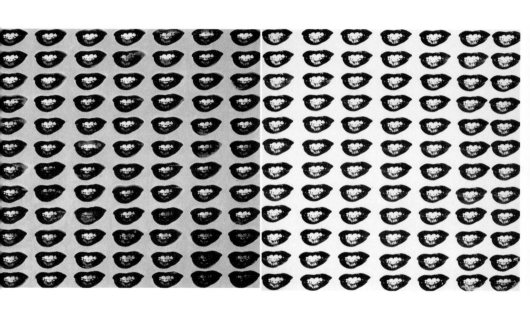

In September 1951 one of his drawings that was reproduced as a full page advertisement in the *New York Times* to advertise a forthcoming radio programme on crime greatly boosted his professional reputation; two years later the design would win him his first Art Director's Club Gold Medal. And in June 1952 the artist held his first exhibition. This was mounted at the Hugo Gallery on East 55th Street and comprised a suite of fifteen drawings based on the writings of Truman Capote.

Peach Halves

———

1962
oil paint, wax crayon on canvas
Staatsgalerie, Stuttgart

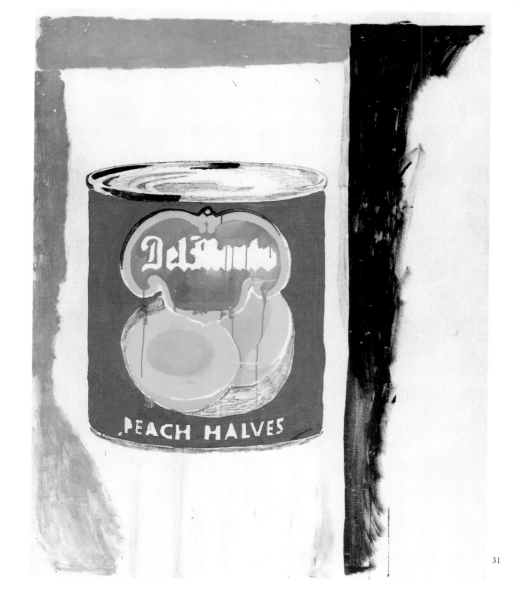

Warhol idolized Capote and he had not been long in New York before he had brought himself to the writer's attention by constantly telephoning or writing to him; eventually Capote gave up trying to ignore the designer. The Capote drawings exhibition gained one or two reviews but Warhol sold nothing. But by now his commercial career was really taking off, and in the spring of 1953 he obtained the services of an agent, Fritzie Miller, who had excellent contacts at up-market magazines such as *Vogue* and *Harper's Bazaar*.

Do It Yourself (Landscape)

1962
acrylic and pencil on canvas, 177.2 x 137.5 cm
Museum Ludwig, Cologne

33

Within a short time Warhol had become the most sought-after fashionware illustrator in New York. He also became very active as a book illustrator, working with Fred McCarroll and Mary Suzuki to adorn *Amy Vanderbilt's Complete Book of Etiquette* and producing privately published books of drawings with whimsical titles such as *A Is an Alphabet* and *Love is a Pink Cake*, upon which he collaborated with one of his boyfriends, Ralph Ward.

Dance Diagram (Fox Trot)

1962
casein and pencil on canvas, 177.8 x 137.2 cm
Onnash collection

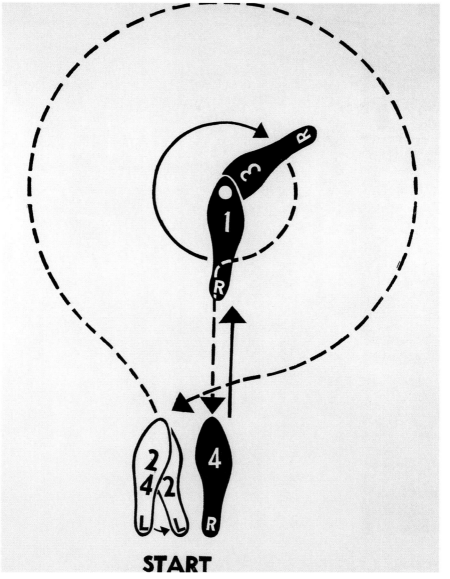

START

Warhol had first discovered his latent homosexuality when he was still a student in Pittsburgh but naturally, within such a relatively narrow-minded and intolerant provincial environment, he had been very guarded about his sexual preferences; in the more open surroundings of New York he felt less inhibited and initially indulged his proclivities to the full, although after the first shock of freedom had worn off he was not particularly promiscuous, and he became even less so as he got older. Yet for the most part he downplayed his sexual persona, and often he sublimated his sexuality into a highly manipulative voyeurism.

One Dollar Bills

1962
silkscreen, acrylic paint and pencil on canvas, 242 x 189 cm
Museum für Gegenwart, Berlin

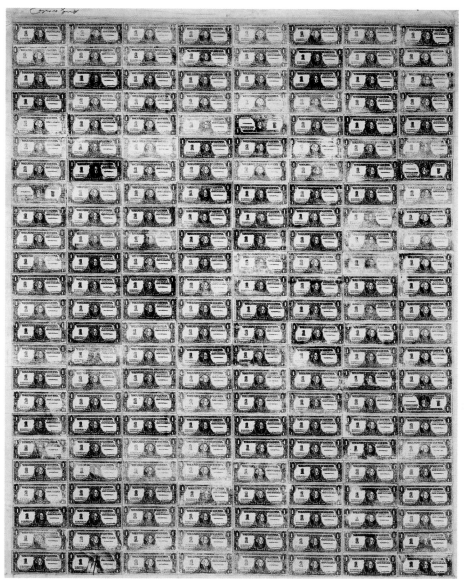

(UPI RADIOTELEphoto)

In 1954 Warhol held three shows of work at the Loft Gallery on East 45th Street. In this year he also published further books, such as *Twenty-five Cats Name [sic] Sam and One Blue Pussy*, which he retailed (along with his drawings) mainly through the Serendipity general store and restaurant on 58th Street. The books never sold in large numbers but they formed very useful presents to art directors when soliciting work, as did a host of other attractive designs and cards.

129 Die in Jet (Plane Crash)

1962
acrylic paint on canvas, 254 x 183 cm
Museum Ludwig, Cologne

New York Mirror

WEATHER: Fair with little change in temperature.

Vol. 37, No 296

MONDAY, JUNE 4, 1962

C

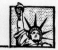

129 DIE

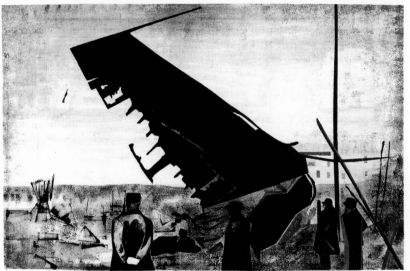

(UPI RADIOTELE photo)

IN JET!

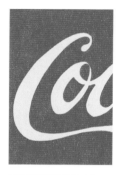

Such self-promotional ploys often paid off, and by 1954 the designer was so busy that he took on a studio assistant. And for a short time Warhol was also instrumental in designing sets and programmes for the *Theater 12* group, and even acted in a couple of its productions, albeit not very well; he did not have the self-confidence to project himself favourably to an audience, although with some careful coaching he did improve in time.

Close Cover Before Striking

1962
acrylic paint on canvas, 183 x 137.2 cm
Louisiana Museum of Modern Art, Humlebaek, Danemark

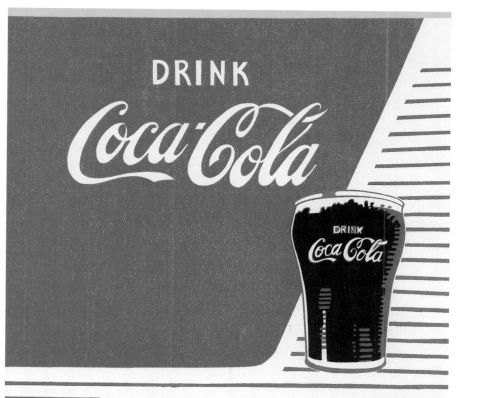

But he appears to have taken a real interest in the theatre, and through his linkage with the *Theatre 12* group he may well have had his attention drawn to Brecht's theories concerning alienation, there certainly being parallels between those theories and aspects of his own mature aesthetic and behaviour.

In 1955 Warhol took his biggest step as an illustrator by obtaining the commission to make a series of designs to appear almost weekly in the *New York Times* Sunday editions for the highly fashionable I. Miller shoe store.

Do It Yourself (Sailboats)

1962
acrylic paint, pencil on canvas, 183 x 254 cm
Daros collection, Switzerland

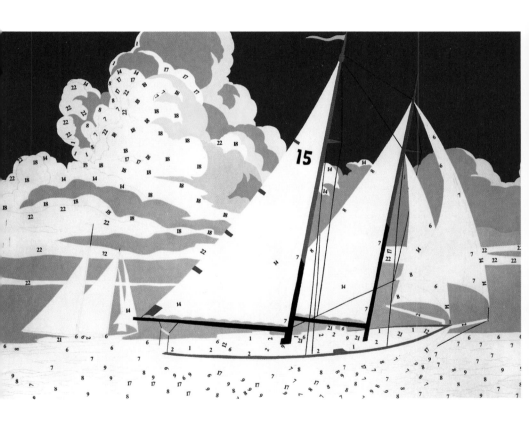

43

Warhol's shoe illustrations created an enormous impact, and this success contributed to his growing income, which in the following year topped $100,000, a huge sum for one so young. The burdens the demands for work placed upon Warhol led him to replace the earlier studio assistant with Nathan Gluck, who would go on working for him until 1964. Gluck had good contacts in the retail trade and he arranged for Warhol to design window displays for the Bonwit Teller department store.

Elvis 49 Times

1962
silkscreen and acrylic on canvas, 204.5 x 146.8 cm
William J. Bell collection

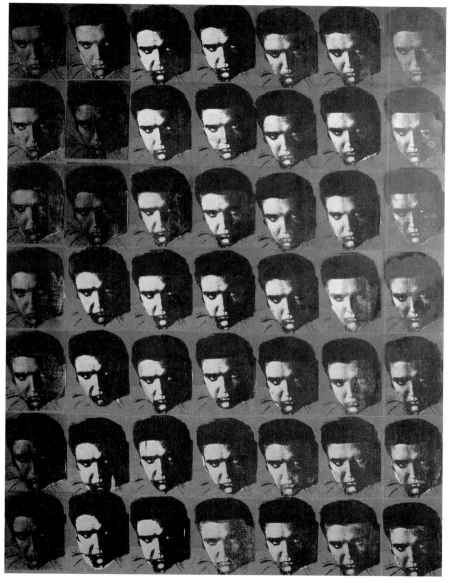

This commission also led Warhol to design window displays for the Tiffany's and I. Miller stores. Warhol sold many of the original I. Miller shoe advertisement drawings through the Serendipity shop, and subsequently he produced a book of highly whimsical drawings of shoes entitled *A la Recherche du Shoe Perdu*, shoes being objects to which he was sexually attracted; in time he would collect hundreds of pairs of them and would enjoy kissing the shod feet of his boyfriends when making love to them.

Close Cover Before Striking
(Pepsi-Cola)

1962
acrylic and pencil on canvas, 182.9 x 137.2 cm
Museum Ludwig, Cologne

say "Pepsi please"

CLOSE COVER BEFORE STRIKING

AMERICAN MATCH CO., ZANSVILLE, OHIO

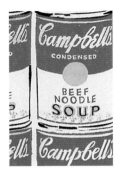

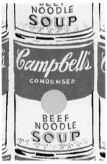

And he was also highly voyeuristic, creating an ongoing series of drawings of sexual organs for a proposed book of 'cock' drawings, as well as a portfolio of studies of beautiful young males and their beribboned private parts which he published under the title of *Drawings for a Boy Book*.

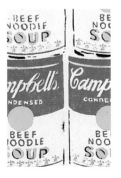

100 Cans

―――――

1962
oil on canvas, 182.8 x 132 cm
Buffalo Art gallery, New York

In February 1956 Warhol held an exhibition of the *Boy Book* designs, as well as the books themselves, at the Bodley Gallery on East 60th Street; he sold only a small number of the drawings but that April the gallery owner, David Mann, managed to get some of Warhol's latest works into the *Recent Drawings U.S.A.* show at the Museum of Modern Art, New York.

Schlitz Cans

1962
casein and pencil on cotton, 175.2 x 137.1 cm
Mugrabi collection

That year Warhol was also awarded the 35th Annual Art Directors Club Award for Distinctive Merit for his I. Miller shoe advertisements. By now Warhol's success had enabled him to become a serious collector of works of art and incunabula; his initial purchases included pieces by Picasso, Braque, Klee and Magritte.

Liquorice Marylin

1962
silkscreen in canvas, 50.8 x 40.6 cm
The Brant Foundation, Greenwich

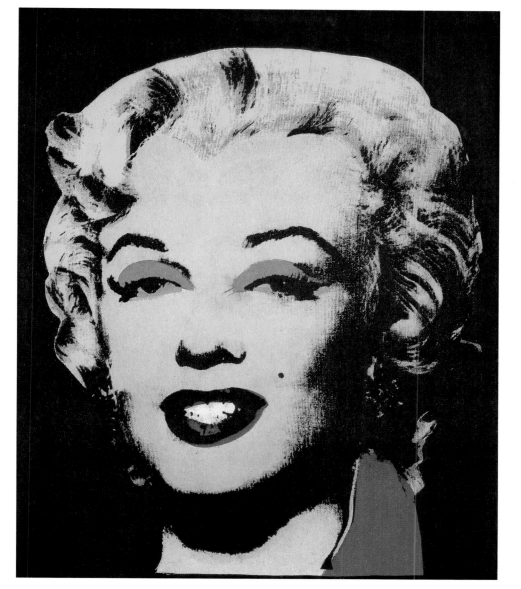

Eventually Warhol's holdings would become immense and be heightened by his refusal ever to throw anything away, as well as be expanded by his proclivity for purchasing in bulk – he could never resist a bargain. (In 1988, after his death, it would take nine days to auction off his collection of thousands of objects in New York.)

Four Marilyns

────────────

1962
silkscreen on canvas, 73.6 x 60.9 cm
Sonnabend collection

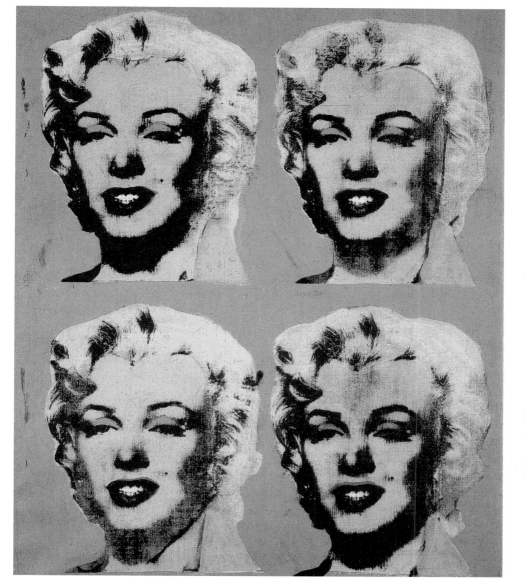

Warhol held another exhibition at the Bodley Gallery in December 1956, entitled the *Crazy Golden Slipper or Shoes Shoe in America*. This comprised a series of gilded shoe images, each with the name of some leading media or showbiz personality attached, such as Truman Capote, Mae West and Elvis Presley. Unlike the previous exhibition, the show was a success, and it not only gained the artist sales but also a two-page spread in *Life* magazine in January 1957.

Marilyn Diptych

1962
acrylic paint on canvas
205.4 x 144.8 cm
The Tate gallery

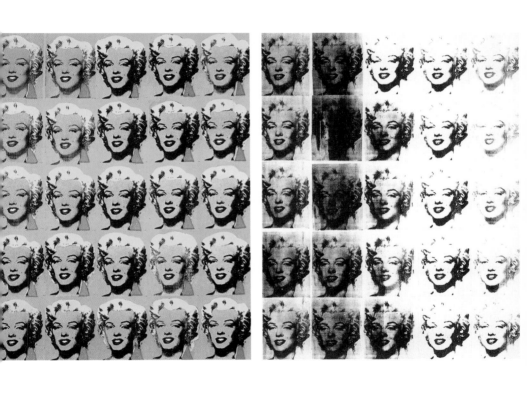

However, Warhol was not too pleased with the coverage, for it described him merely as a 'commercial artist' and already he entertained higher ambitions. Yet for the time being he ploughed on with his highly profitable career as a designer, and later that year he received further recognition not only by winning an Award for Distinctive Merit from the New York Art Directors Club for one of his I. Miller shoe advertisements but also their 36th Annual Art Directors Club Medal for his radio crime programme advertisement of two years earlier.

Men in Her Life

1962
silkscreen et pencil on plywood, 214.6 x 211.5 cm
Private Collection, Japan

At the end of 1957 Warhol held yet another exhibition of gilded drawings at the Bodley Gallery, and he published the related *Gold Book* as a Christmas self-promotional item. But just four weeks later, in January 1958, an exhibition opened at the Leo Castelli Gallery in New York that would ultimately change Warhol's entire life. This was the first largescale showing of Jasper Johns's paintings of the American flag, and of targets and numbers.

Green Car Crash

1962
silkscreen and pencil on canvas, 213.4 x 208.3 cm
Private Collection

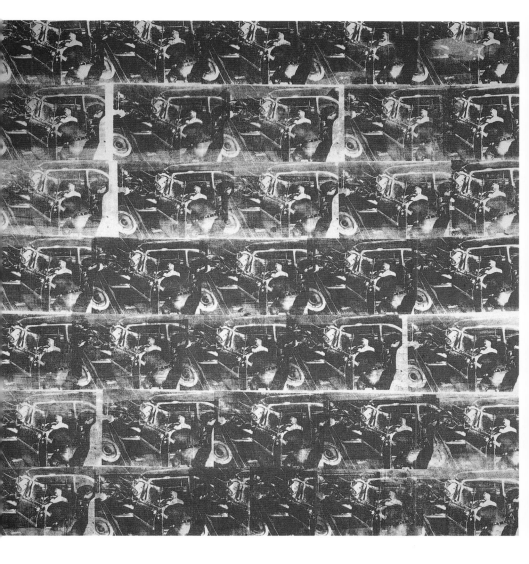

The challenge such images offered to the prevailing aesthetic trend of the day was consolidated a mere two months later by an exhibition (also held at the Castelli Gallery) of works by Robert Rauschenberg. Between them these two artists brought about a radical break with the direction that recent American art had been taking.

Flowers

———

1962
silkscreen on canvas, 62.2 x 62.2 cm
Sonnabend collection

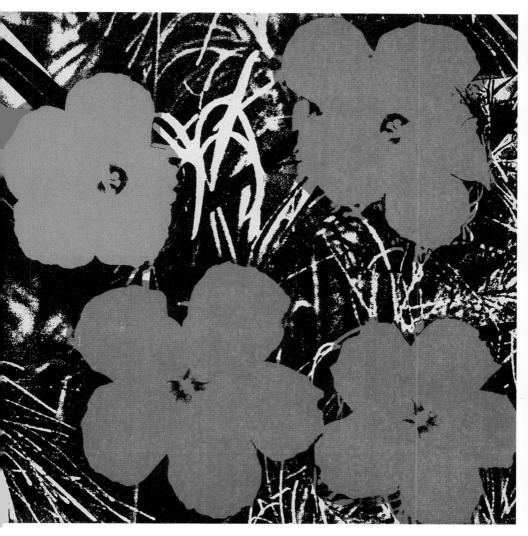

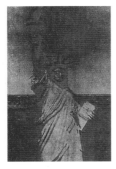

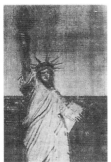

The Johns and Rauschenberg shows of 1958 gave Warhol an intense desire to break with 'commercial' art and instead become a fine artist, although by now his financial commitments were so huge that it took him at least two more years to make that break. In 1959 he lost the I. Miller shoe account, due to a company decision to use photographs rather than drawings for the advertisement illustrations.

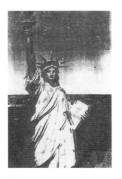

Statue of Liberty

———————

1963
silkscreen ink, acrylic paint on canvas
-Daros collection, Switzerland

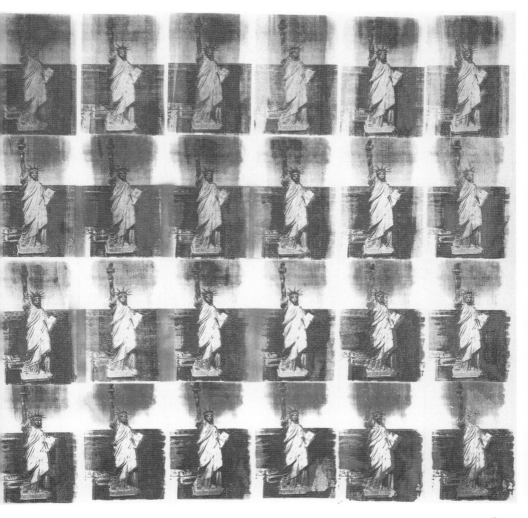

Yet Warhol still had plenty of other advertising work, and also in 1959 he received the Certificate of Excellence from the American Institute of Graphic Arts for his previous year's output. That autumn he published a joke cookbook, *Wild Raspberries*, the text for which was provided by Suzie Frankfurt, and in December 1959 he held an exhibition of the book designs at the Bodley Gallery, although by now there was little market for such offerings; New York taste was moving away from Warhol's fey imagery.

Silver Liz

———

1963
acrylic and silkscreen on canvas, 101.6 x 101.6 cm
The Brant Foundation, Greenwich

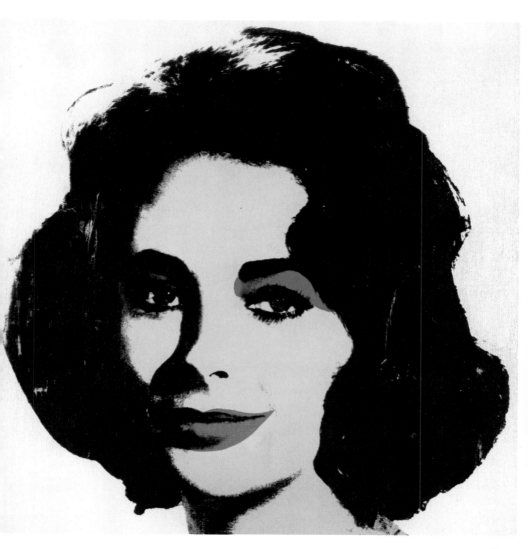

Faced with this marginalisation, and by the growing acclaim that was being accorded to artists such as Johns and Rauschenberg, Warhol felt increasingly desperate about the creative *cul de sac* into which he was heading. This mood galvanised him into action. From late 1959 onwards he slaved away at oil paintings during his spare time in the hope that something would emerge. He began painting mass-culture objects such as Coca-Cola bottles, refrigerators and television sets, and he also appropriated imagery from cheap advertisements and comic strips.

5 Deaths on Yellow
(Yellow Disaster)

———————

1963
silkscreen on canvas, 76.5 x 76.5 cm
Sonnabend collection

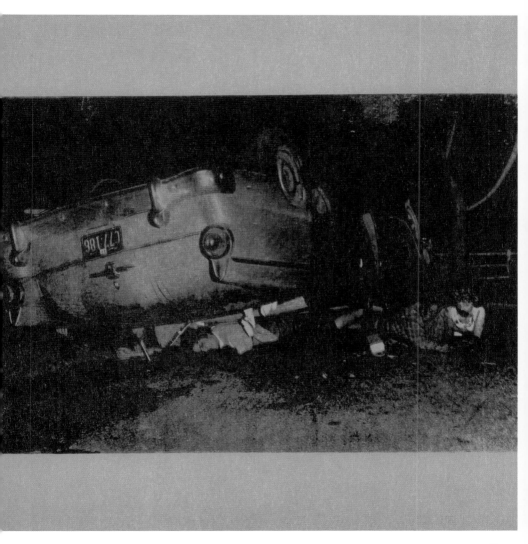

In such works he was inspired by the work of Jasper Johns.

By now Warhol's commitment to painting was costing him dearly, for he was neglecting his commercial art opportunities; as a result, in 1960 his income went down to a paltry $60,000 which his lavish lifestyle quickly gobbled up. Yet in the final analysis money wasn't Warhol's most pressing need; he wanted fame, and to achieve that he required an imagery that would force the world to take him seriously as an artist.

Double Elvis

1963
silkscreen ink, silver paint on canvas, 210.2 x 222.3 cm
Museum für Gegenwart, Berlin

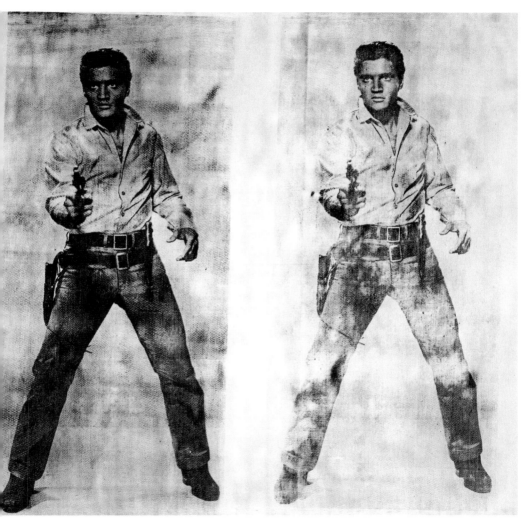

By the end of 1961 he was no nearer to fulfilling that need than he had been at the outset of his fine art career, and he became deeply depressed because of it. Throughout the New York art scene a new wave of painters and sculptors was making itself known through its adoption of imagery from mass-culture, and Warhol was in danger of getting left behind. But finally the problem resolved itself one evening in December 1961. Warhol got talking to an interior decorator and gallery owner, Muriel Latow, who supplied exactly what he needed, albeit at a price:

Gangster Funeral

1963
silkscreen ink, acrylic paint and pencil on canvas,
266.7 x 187.3 cm
The Andy Warhol Museum, Pittsburgh

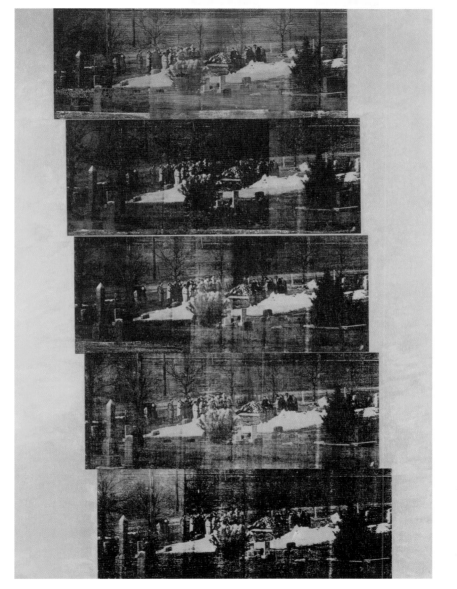

...Seized shipment: Di...

...Andy said, "I've got to do something...The cartoon paintings ...it's too late. I've got to do something that really will have a lot of impact, that will be different enough from Lichtenstein and Rosenquist, that will be very personal, that won't look like I'm doing exactly what they're doing....I don't know what to do. So, Muriel, you've got fabulous ideas. Can't you give me an idea?" And Muriel said, "Yes, but it's going to cost you money." So Andy said, "How much?" She said, "Fifty dollars....get your checkbook and write me a check for fifty dollars."

Tunafish Disaster

———————

1963
silkscreen ink, acrylic paint on canvas, 316 x 211 cm
Daros collection, Switzerland

Seized shipment: Did a leak kill . . Seized shipment: Did a leak kill . . Seized shipment: Did a leak kill . . .

Seized shipment: Did a leak kill . . Seized shipment: Did a leak kill . . Seized shipment: Did a leak kill . . .

And Andy ran and got his checkbook, like, you know, he was really crazy and he wrote out the check. He said, "All right, give me a fabulous idea." And so Muriel said, "What do you like more than anything else in the world?" So Andy said, "I don't know. What?" So she said, "Money. The thing that means more to you and that you like more than anything else in the world is money. You should paint pictures of money." And so Andy said, "Oh, that's wonderful". "So then either that or," she said, "you've got to find something that's recognizable to almost everybody.

Ethel Scull Triptych

———————

1963
silkscreen, acrylic paint on canvas, 50.8 x 40.6 cm
Mugrabi collection

Something that you see every day that everybody would recognise. Something like a can of Campbell's soup". So Andy said, "Oh, that sounds fabulous." So, the next day Andy went out to the supermarket (because we all went by the next day), and we came in, and he had a case of...all the soups. So that's how [Warhol obtained] the idea of the Money and Soup paintings.

Thirty Are Better Than One

1963
silkscreen ink, acrylic paint, silver paint on canvas,
279.4 x 240 cm
The Brant Foundation, Greenwich

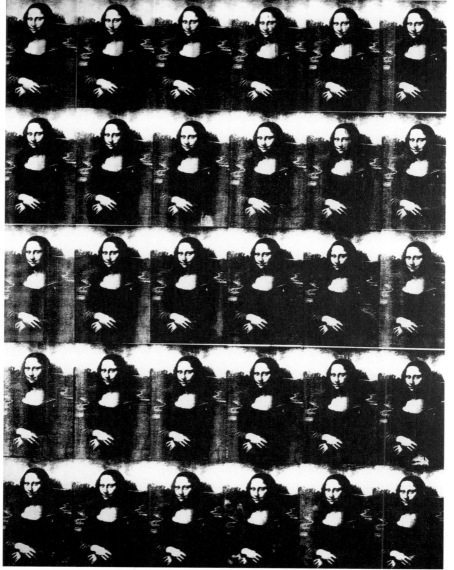

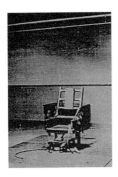

Warhol immediately set to work painting pictures of both money and of cans of Campbell's soup. As Latow was well aware, the latter objects were especially close to Warhol's heart, for he had lunched on soup and crackers every day for over twenty years.

All through the winter and spring of 1962 Warhol worked on pictures of dollars in various combinations, both as individual bills and in rows, and also upon a set of 32 small canvases that individually featured the 32 different varieties of Campbell's soups, each on a blank background.

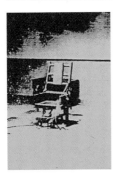

Orange Disaster #5

————————

1963
acrylic, silkscreen on canvas
The Solomon R. Guggenheim Museum, New York

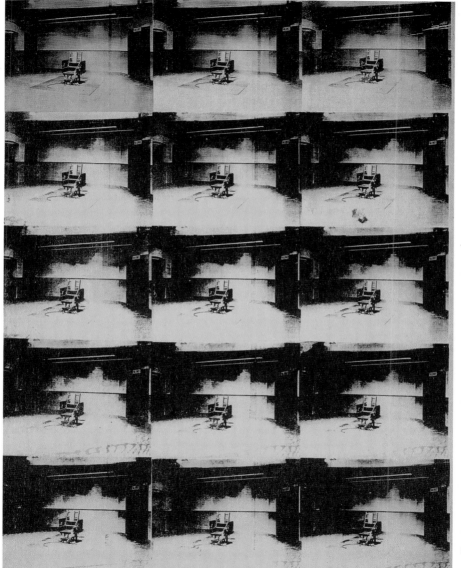

And this is where Warhol's conceptual and visual genius took over from Muriel Latow's original idea, for the deadpan arrangement of the images enforced a rigid disconnection from emotion, whilst the machine-like appearance of the images was an exact analogue for the industrial processes that had brought the objects they represented into being in the first place.

Ethel Scull

————

1963
silkscreen on canvas, 210.8 x 179.1 cm
Mugrabi collection

Warhol was making a comment upon the bloodless imagery of the machine age through directly reflecting its mechanistic divorce from emotion by means of his own imagery. Such imagistic mechanisation probably reflected a social mechanisation as well, for as he related in 1963:

Someone said Brecht wanted everybody to think alike. I want everybody to think alike....Everybody looks alike and acts alike, and we're getting more and more that way.

Blue Shot Marylin

—————————

1964
silkscreen and synthetic paint on canvas, 101.6 x 101.6 cm
The Brant Foundation, Greenwich

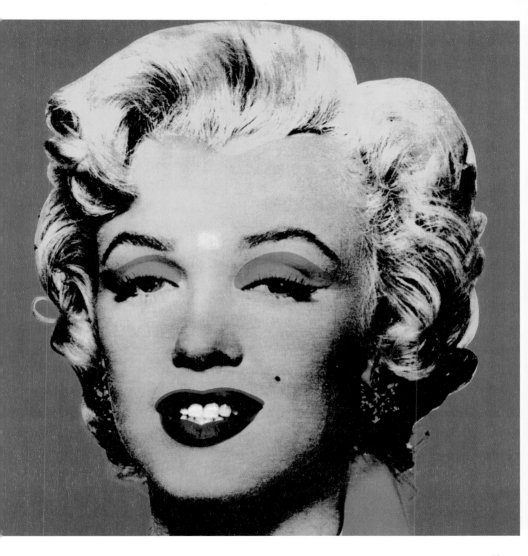

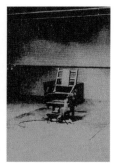

I think everybody should be a machine...because you do the same thing every time. You do it again and again.... History books are being rewritten all the time. It doesn't matter what you do. Everybody just goes on thinking the same thing, and every year it gets more and more alike. Those who talk about individuality the most are the ones who most object to deviation, and in a few years it may be the other way round. Some day everybody will think just what they want to think, and then everybody will probably be thinking alike; that seems to be what is happening.

12 Electric Chairs

1964-1965
silkscreen and acrylic on canvas, 12 panels, 55.8 x 71.1 cm
The Brant Foundation, Greenwich

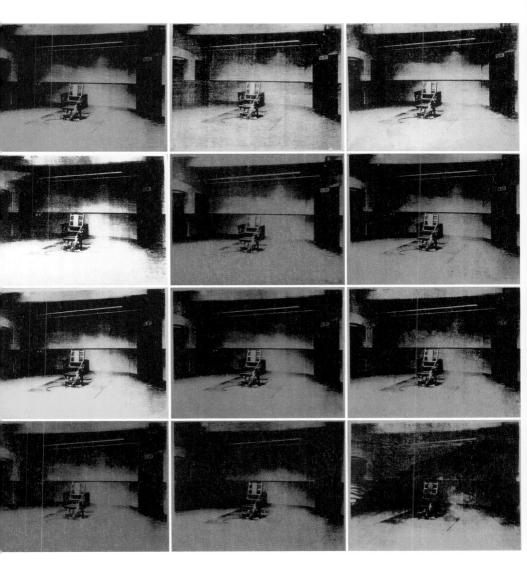

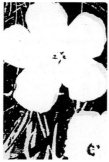

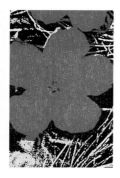

And in his paintings Warhol was also making larger points about the repetitiousness and conformism that underlies much of modern life generally, just as through repetitiousness and visual patterning his pictures were making exactly those selfsame points about the imagery of mass-culture and the reality behind it.

Throughout the late spring and early summer of 1962 Warhol laboured on his canvases, making large pictures of individual soup cans, teach-yourself-to-dance diagrams and paint-by-numbers images.

Flowers

———

1964
silkscreen on canvas, 16 panels, each 20.3 x 20.3 cm
Sonnabend collection

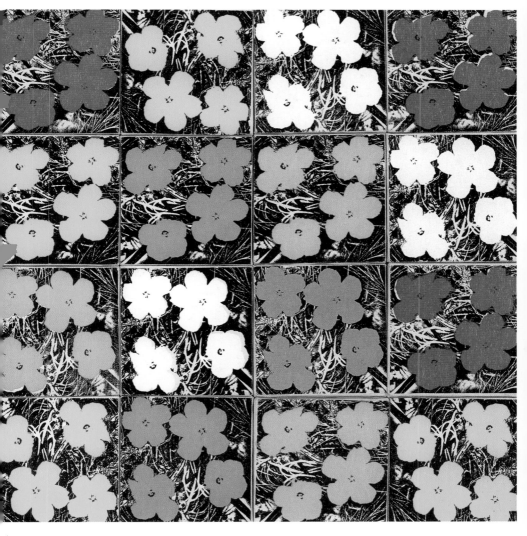

He also further extended his subject-matter by depicting serried ranks of Coca-Cola bottles, S & H Green Stamps, airmail stamps and stickers, and 'Glass – Handle with Care' labels. And simultaneously he moved in a different direction too. On 4 June 1962 Warhol lunched at Serendipity with Henry Geldzahler who told him.

16 Jackies

1964
silkscreen ink, acrylic paint on canvas
16 panels, each 50.8 x 40.6 cm
The Brant Foundation, Greenwich

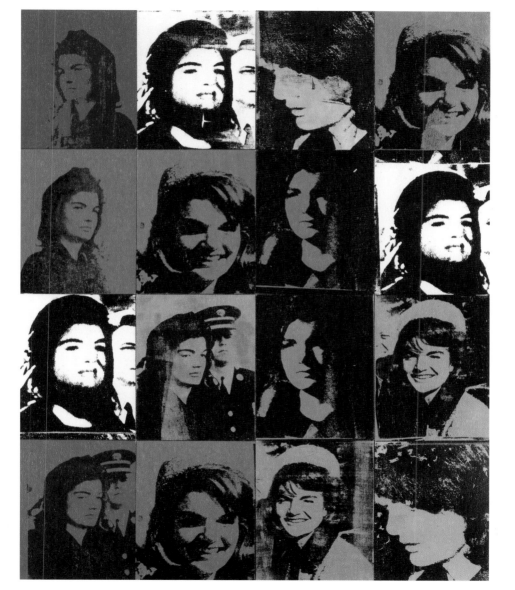

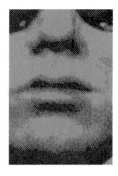

That's enough affirmation of life....It's enough affirmation of soup and Coke bottles. Maybe everything isn't so fabulous in America. It's time for some death. This is what's really happening. Geldzahler then handed Warhol a copy of that morning's *Daily News* which carried the headline '129 DIE IN JET!' Once again Warhol immediately grasped the underlying cultural implications of such imagery and created a painting of the selfsame front page. It was to be the first of his many disaster pictures.

Self-Portrait

1964
silkscreen ink, acrylic paint on canvas, 50.8 x 40.6 cm
Private Collection

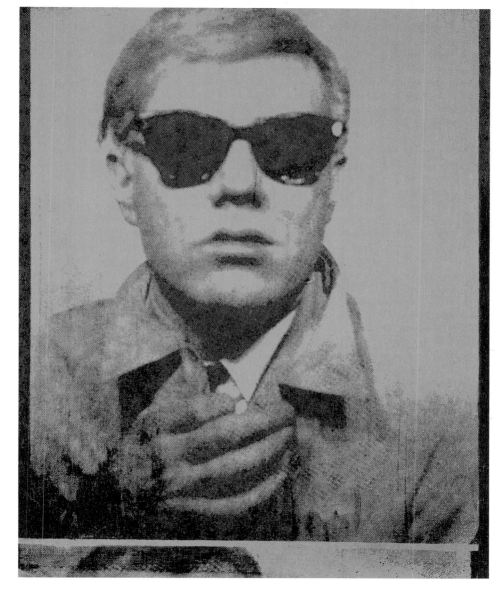

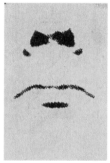

Yet in common with the other reproductions of newspaper front pages that Warhol made around this time, and many of the further works depicting objects in daily use that he was simultaneously producing, because *129 Die in Jet!* was hand-painted and therefore not as mechanistic-looking as its prototype, inevitably it looks subjective.

Self-Portrait
———————
1964
silkscreen ink, acrylic paint on canvas, 50.8 x 40.6 cm
Private Collection

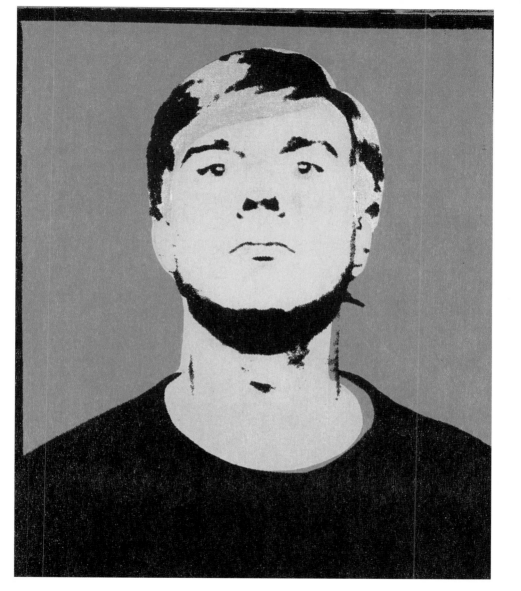

In an attempt to counter this problem, and equally to help streamline the process of reproducing visually complex objects such as dollar bills, Coke bottles, Green Stamps, airmail stickers and the like *en masse*, several of those types of images were initially produced using handcut stencils or rubber stamps and wood blocks, all devices that Warhol had used in his former life as an illustrator.

Self-Portrait

1964
silkscreen ink, acrylic paint on canvas, 183 x 183 cm
Froehlich collection, Stuttgart

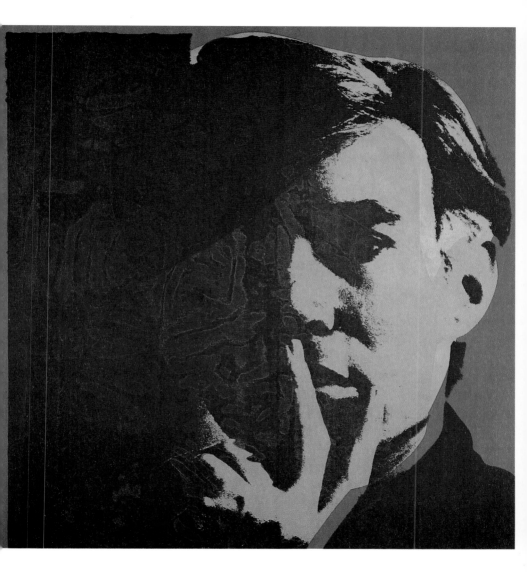

But the gap between hand-made and machine-made images was truly closed in July 1962 when Nathan Gluck suggested that if Warhol really wanted to cut out the laboriousness of producing repetitive images, he should use the photo-silkscreen printing technique instead.

With this method a photographic image is transferred to a screen of sensitised silk stretched on a frame, and the fine mesh of the silk permits ink or paint to pass through it onto a canvas or other support only where it is not protected by a membrane of resistant gum.

Most Wanted Men n° 11,
John Joseph H.

———————

1964
silkscreen ink on two canvases, each 122 x 101.5 cm
Saatchi collection, London

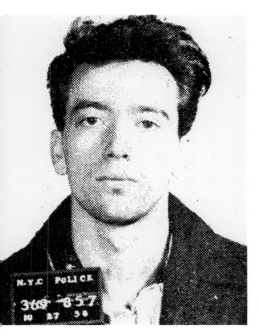

The use of silkscreen printing meant that Warhol could now incorporate mechanical repetition directly into his work, rather than indirectly through painting each image slowly by hand, or by means of handcut stencils, stamps and blocks. It thereby allowed him to address to the full the 'quantity and repetition' he saw as being the essential content of his art, in addition to achieving the 'assembly line effect' he wanted.

Campbell's Tomato Box

1964
oil on wood, 25.4 x 48.2 x 24.1 cm
Paul Warhol collection

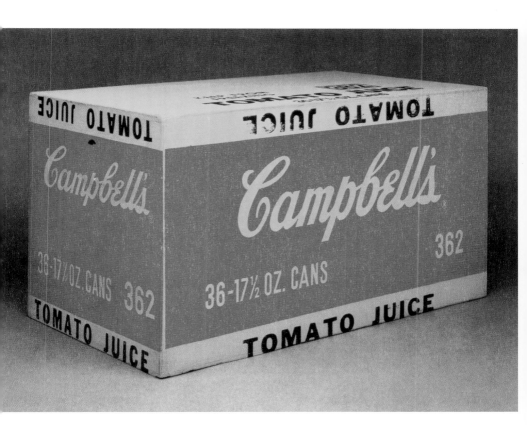

Such a process necessarily imparted a mechanical look to the images, although Warhol was careful to guard against that mechanisation becoming too sterile by encouraging variations in inking and printing overlaps. The uneven inking simultaneously introduces associations of the kind of irregularity that frequently occurs at the proofing stages of mechanical printing, while the overlaps exactly emulate the arbitrary overlaps of commercial printer's trial proof sheets.

Cagney

1962
silkscreen on paper, 76.2 x 101.6 cm
Mugrabi collection

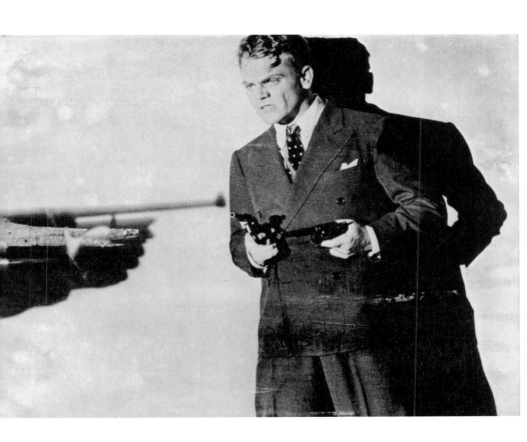

Naturally Warhol had seen such unevenness of inking and image overlaps innumerable times during his commercial art career, and he had come to apprehend such trial proofings as alternative subjects to the comic strips being dealt with contemporaneously by Roy Lichtenstein, with their emulation of printing dot techniques. Moreover, the overlaps and extreme tonal ranges of density in the inking add great visual variety, immediacy and movement to the images.

Jackie

———

ca. 1964
synthetic paint and silkscreen on canvas, 50.8 x 40.6 cm
Mugrabi collection

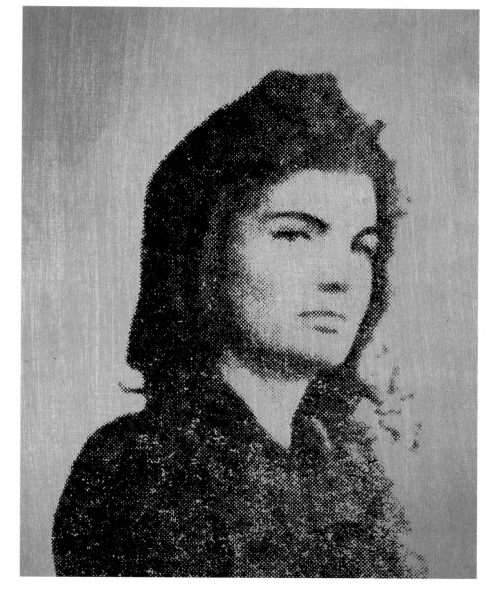

As a result of the use of photo-silkscreen, Warhol could now deal with a much vaster range of imagery, including the representation of people whose likenesses would have been much harder to arrive at accurately by hand, and the approximation of whose appearances would inevitably have introduced an unintended personality to the imagery through the necessary 'touch' of the artist when making the pictures.

Nine Jackies

———

1964
silkscreen on canvas, 152.4 x 122.3 cm
Sonnabend collection

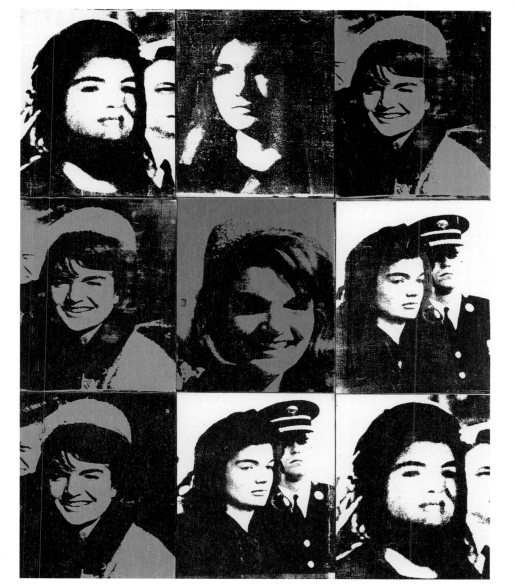

By using photo-silkscreen, Warhol the 'machine' came one step closer to achieving full realisation, with the extra advantage that if necessary the artist could utilise the labour of others in order to help him create the images, as well as enable him to work easily on a comparatively vast scale.

July 1962 was also an important month for Warhol for another reason, for he then mounted his first one-man show as a fine artist.

Race Riot

1964
acrylic paint and silkscreen on canvas, 84 x 84 cm
Angelo Baldassari collection, Bari

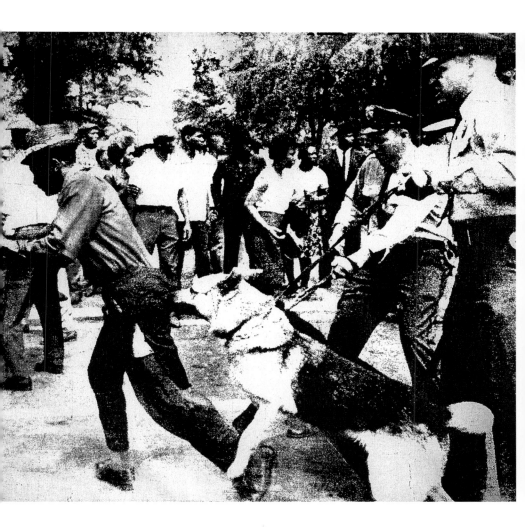

This took place in Los Angeles, at the Ferus Gallery, and comprised just the 32 Campbell's soup paintings. The exhibition only received limited critical coverage, but it was moderately successful in terms of sales (although all the pictures were eventually bought back and the ensemble re-constituted.)

The very day the Los Angeles show ended – 4 August 1962 – Marilyn Monroe committed suicide and so Warhol immediately began a series of silk-screened pictures of her that were destined to become his most famous images.

Flowers

———

1964
silkscreen ink on two canvases, each 12.7 x 12.7 cm
Sonnabend collection

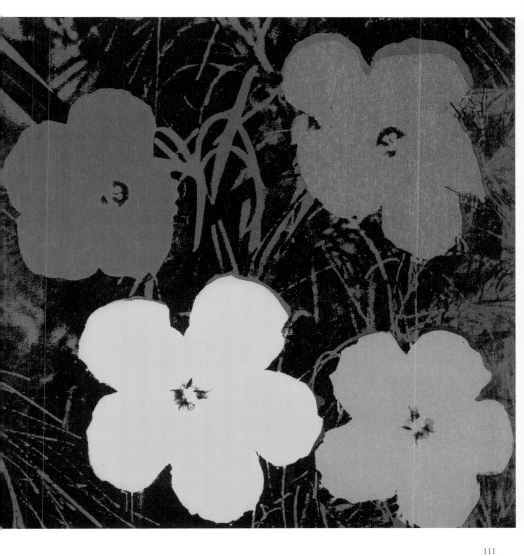

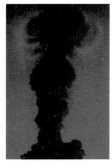

In the Marilyns, Warhol heightened the garishness of the film actress's lipstick, eyeshadow and peroxide blonde hairdo, obviously to make points about the garishness of 'glamour' and stardom, while in many of the works repetition plays a crucial role, obviously to mirror the visual repetitiousness through which Marilyn Monroe had habitually been presented to the world.

Atomic Bomb

1965
silkscreen ink, acrylic paint on canvas, 264.2 x 204.5 cm
Daros collection, Switzerland

Once the Marilyns series was completed, Warhol used the silkscreen technique to create further sets of the soup cans, Coke bottles, coffee cans and dollar bills images he had so laboriously painted earlier that year, as well as embarking upon new sets of images of movie and pop music stars such as Liz Taylor, Marlon Brando and Elvis Presley.

Four Colored Campbell's
Soup Cans

1965

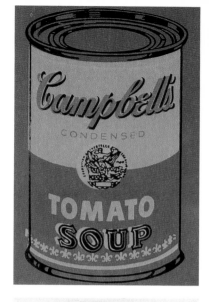
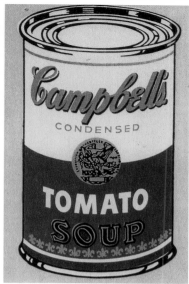
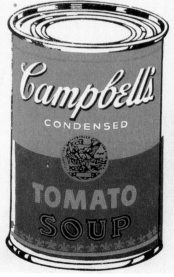
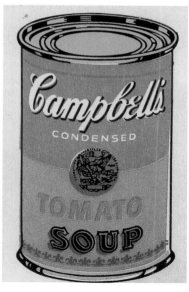

All this hard work soon paid off, for in November 1962 Warhol at last showed his fine-art work in New York, at Elinor Ward's Stable Gallery on West 58th Street. On view were eighteen pictures, including the *Gold Marilyn*, *129 Die in Jet!*, a *Dance Diagram* painting placed on the floor with an invitation to dance over it, the *Red Elvis*, and several Coca-Cola bottles and soup can pictures.

Double Self-Portraits

1966-1967
silkscreen ink on two panels, each 55.9 x 55.9 cm
The Brant Foundation, Greenwich

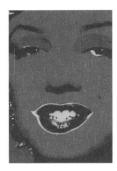

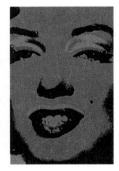

The exhibition was an almost total sell-out, for it generated enthusiastic responses that were worthy of the artist's highest aspirations down the years. Never again would Warhol leave the public eye during his lifetime.

In February 1963 the Metropolitan Museum of Art in New York put Leonardo da Vinci's *Mona Lisa* on display for a month, and Warhol thereupon made some paintings incorporating the image, one of which is reproduced below. These pictures not only debunk the cultural status of the Leonardo but equally stress the vast mass-media dissemination of the original image.

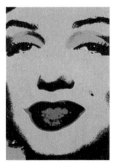

Marilyn

————

1967
portfolio containing nine silkscreen, 91.5 x 91.5 cm each
Private Collection

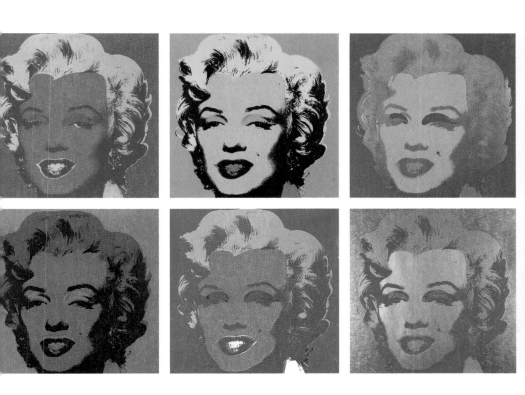

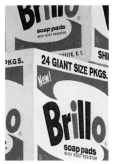

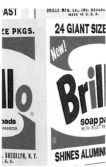

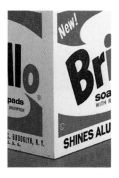

And in May 1963, when racial tension in the American South was at its height due to the struggle for black civil rights, Warhol developed a series of paintings of police dogs savaging blacks in Birmingham, Alabama, before going on throughout that summer and the rest of the year to explore the related implications of deaths and disasters in a long series of images of suicides, car crashes, gangster funerals, electric chairs, fatalities caused by food poisoning, atomic explosions and, after December 1963, Jackie Kennedy at the presidential funeral of her husband less than a month earlier.

Brillo Boxes

1969
silkscreen ink on plywood, 50.8 x 50.8 x 43.2 cm
Norton Simon Museum, Pasadena, California

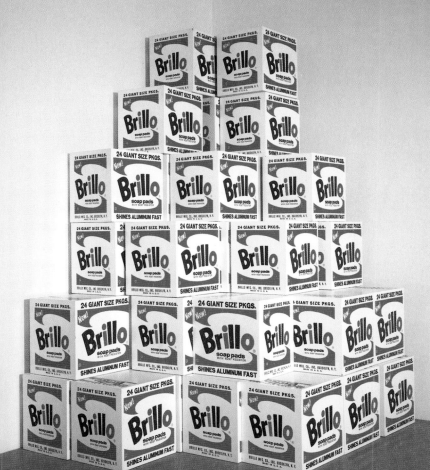

As Warhol stated:

I realized that everything I was doing must have been Death. It was Christmas or Labor Day – a holiday – and every time you turned on the radio they said something like, "4 million are going to die." That started it. But when you see a gruesome picture over and over again, it doesn't really have any effect. The death series I did was divided in two parts:

Philip Johnson

—————————

1972
synthetic paint and silkscreen on canvas, 4 works, 81.2 x 81.2 cm
Mugrabi collection

the first on famous deaths and the second on people nobody ever heard of and I thought that people should think about some time: the girl who jumped off the Empire State Building or the ladies who ate the poisoned tuna fish and people getting killed in car crashes. It's not that I feel sorry for them, it's just that people go by and it doesn't really matter to them that someone unknown was killed so I thought it would be nice for those unknown people to be remembered.

Marella Agnelli

1972
synthetic paint and silkscreen on canvas, 2 works,
101.6 x 101.6 cm
The Andy Warhol museum, Pittsburgh

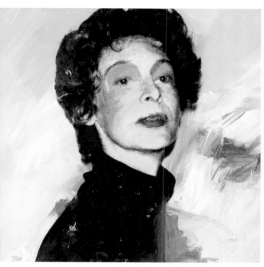

As well as addressing our indifference to the deaths of people unknown to us, in almost all of Warhol's Death and Disaster pictures the visual repetitiousness makes cultural points about the way we habitually encounter tragic or horrific imagery through the mass-media, whilst the fact that for most of us such imagery is intriguing throws back in our faces the morbidity, vicariousness or prurience of our interest in unnatural deaths and disasters.

Mao
———
1973
silkscreen ink, acrylic paint on canvas, 127 x 106.6 cm
Private Collection

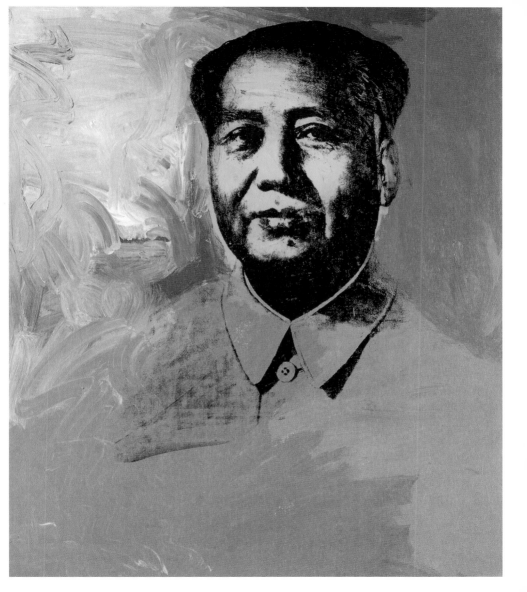

The use of colour also importantly contributes to the associations of such imagery, as does the fact that Warhol coupled many of the paintings with a complementary canvas painted blankly with the same background colour. Ostensibly he did so to give purchasers of the works twice as much painting for the same money, but behind this apparently cynical motive it is possible to detect another, more darkly thought-provoking and completely serious rationale: the blankness of each complementary image projects the cosmic meaninglessness of the accidental or manmade tragedies that are represented alongside.

Vote McGovern

1973
screenprint, 106.7 x 106.7 cm
Gemini GEL, Los Angeles

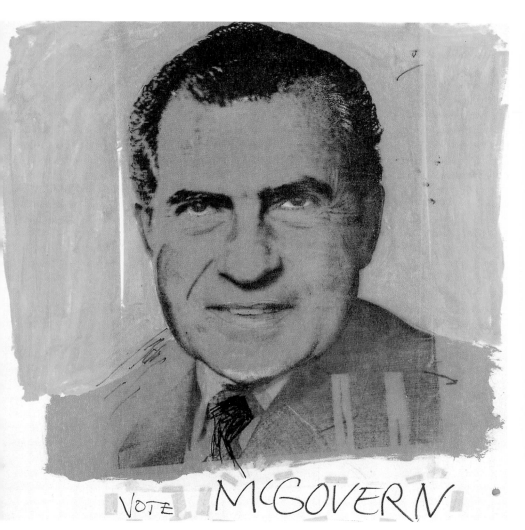

VOTE MCGOVERN

Warhol's next artistic offerings were six vast sets of reproduction outer packing cartons, of the type that serve to transport commodities from factories to supermarket storerooms. When Warhol exhibited them in April 1964 at the Stable Gallery he filled the space virtually from floor to ceiling with the works, thus making the gallery look exactly like a supermarket storeroom.

Mao

———

1973
synthetic paint and silkscreen on canvas, 127 x 106.7 cm
Gagosian gallery, New York

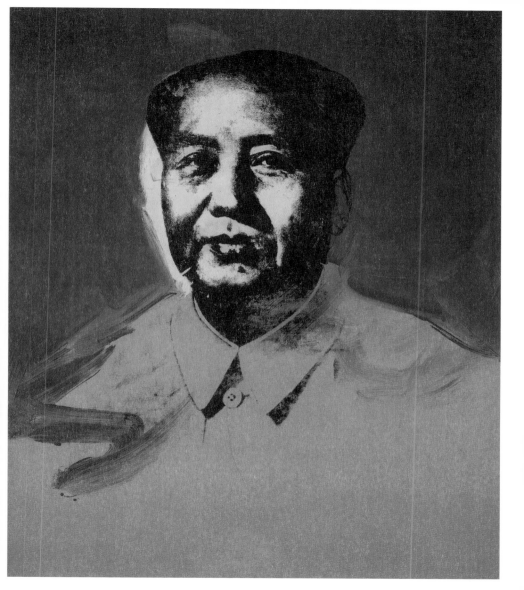

The packing carton sculptures greatly furthered the statements that Warhol had already made in his paintings about mass-culture and mass-production, the imagery of packaging and the mechanisation of imagery, as well as advancing the assaults on fine-art values those statements represented.

Moreover, within the context of an art gallery – or art storeroom – they equally pointed up the very commercialisation of art itself.

Mao

———

1973
silkscreen ink, acrylic paint on canvas, 448.3 x 346.7 cm
The Metropolitan museum of Art, New York

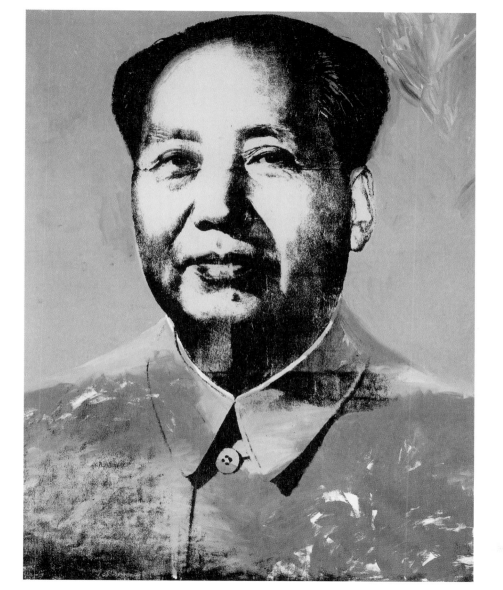

By the time the carton sculptures exhibition opened to some controversy, Warhol had anyway stirred up controversy elsewhere in New York by creating a mural for the New York State Pavilion at the World's Fair in Flushing Meadows. This comprised a series of blown-up police mug-shots of criminals but the work was deemed to be libellous and Warhol was therefore asked to remove it, although rather than do so he simply had it painted over.

Brooke Hayward

1973
acrylic paint and silkscreen on canvas, 4 panels, each
102 x 102 cm
The Tate gallery, London

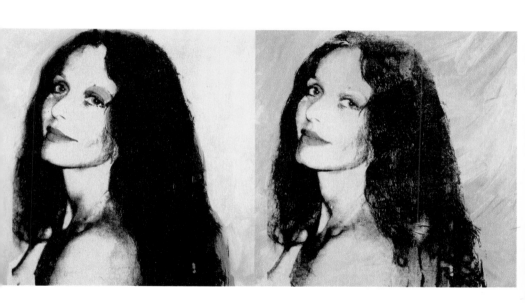

And Warhol's innate desire to confound expectations surfaced yet again in his next New York exhibition held in November 1964. Once more the painter had taken Henry Geldzahler's advice on subject-matter, for just as the art curator had motivated him to deal with death and disaster in 1962, so now he felt that Warhol had painted enough gloom-laden pictures and should paint flowers instead.

Man Ray

———

1974
silkscreen ink, acrylic paint on canvas, 101 x 101 cm
Private Collection

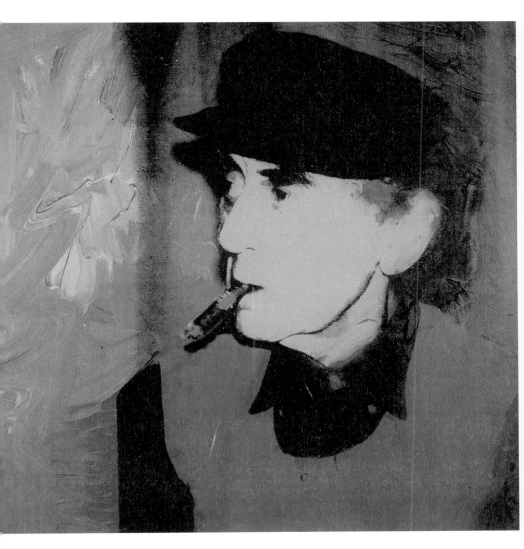

Naturally there was nothing offensive about such imagery, and it may be that Warhol responded with alacrity to Geldzahler's suggestion because the public might prove to be more financially receptive to pictures of flowers than they had been to images of death and disaster or to reproductions of supermarket artifacts. In the event, the show was a complete sell-out, which Warhol must have doubly welcomed, for as a painter he had never yet matched his income as a commercial designer in the 1950s.

Gilbert and Georges

1975
synthetic paint and silkscreen, 2 panels, 101.6 x 101.6 cm
Anthony d'Offay, London

Due to Warhol's increased involvement in filmmaking in 1965, the artist did little painting that year, although he did produce a new set of Campbell's Soup Can paintings in which he greatly departed from the actual colours used for the labels of such objects. But by the end of that year Warhol was beginning to run out of ideas. One day he got into conversation with Ivan Karp:

Ladies and Gentlemen

1975
synthetic paint and silkscreen, 101.6 x 127 cm
Mugrabi collection

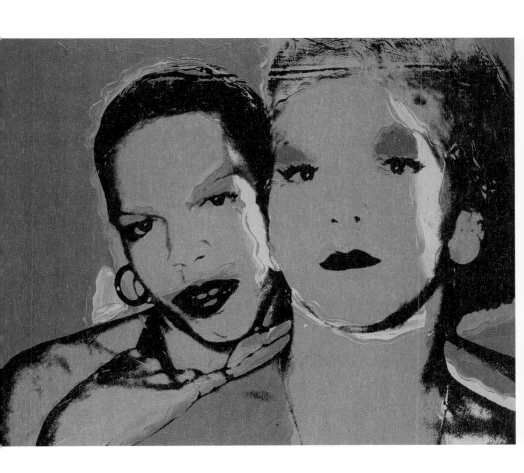

Warhol said that he was using up images so fast that he was feeling exhausted of imagination....he said , "I'm running out of things....Ivan, tell me what to paint!" And he would ask everybody that. He asked Henry [Geldzahler] that. He asked other people that he knew. He asked, "What shall I paint? What's the subject?" I couldn't think of anything. I said, "The only thing that no one deals with now these days is pastorals....My favourite subject is cows." He said, "Cows....Of course! Cows! New cows! Fresh cows!"

Ladies and Gentlemen

1975
synthetic paint and silkscreen, 127 x 101.6 cm
Mugrabi collection

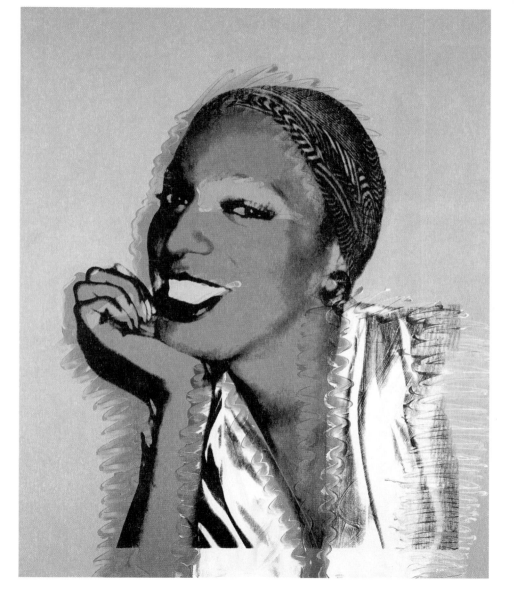

At the artist's behest, a studio assistant found a suitable bovine image in an old agricultural magazine. Subsequently this was made up as wallpaper which was used to cover the walls of one of the two rooms in Warhol's next exhibition, held in April 1966. With its particularly dumb look, the image brings to an absurd end the pastoral tradition in Western art.

Skull

———

1976
silkscreen ink, acrylic paint on canvas, 6 panels, each
38.1 x 47.6 cm
Anthony d'Offay Gallery, London

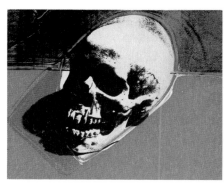
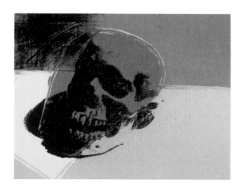
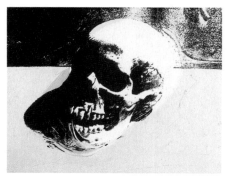

It also fixes Warhol's negative view of picture-making by 1966, for by then the artist was disillusioned with the creation of fixed images, and the installation undoubtedly projected his view that the only remaining role for wall-hung works of art was as decorative wallpaper; as he stated, when asked whether homes or art galleries provided better settings for his pictures: 'It makes no difference – it's just decoration'. That view is understandable in the mass-culture in which we live, for indubitably paintings and their reproductions are mostly used these days as just so much decorative wall covering.

Cocker Spaniel

1976
synthetic paint and silkscreen, 127 x 101.6 cm
Galleria Cardi & Co, Milan

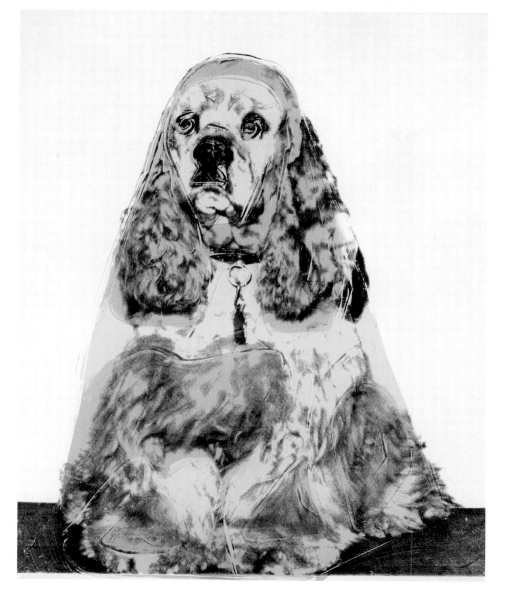

The other half of the 1966 show consisted of a roomful of silver, helium-filled balloons called *Silver Clouds* that floated around aimlessly. Initially Warhol had wanted these objects to be floating light bulbs – he owned a drawing of a horizontally-reclining light bulb by Jasper Johns – but this did not prove to be technically feasible and so he settled on the more easily realisable pillow-shaped forms instead.

Hammer and Sickle

1976
synthetic paint and silkscreen, 182.8 x 218.4 cm
Mugrabi collection

149

They were certainly at the aesthetic cutting edge of sculpture at the time, for they linked to contemporary developments in kinetic sculpture and, by dint of the fact that spectators could touch them, in participatory sculpture as well (indeed, in 1968 Merce Cunningham would use the objects in his ballet *Rain Forest*). Warhol said of these works:

I didn't want to paint any more so I thought that the way to finish off painting for me would be to have a painting that floats, so I invented the floating silver rectangles that you fill up with helium and let out of your windows.

Hammer and Sickle

1976
synthetic paint and silkscreen, 182.8 x 203.2 cm
Mugrabi collection

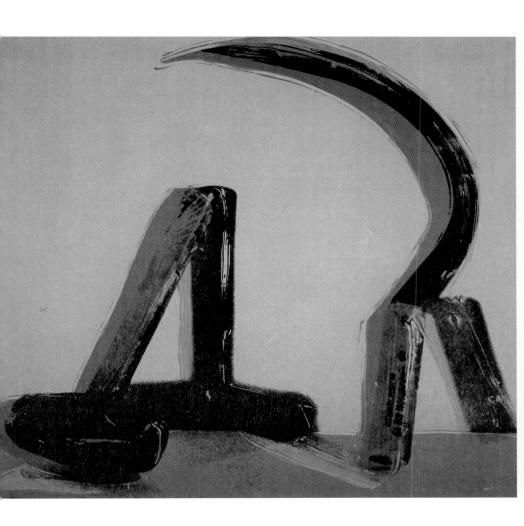

Warhol also claimed that the *Silver Clouds* were intended for people with too many possessions, who only had to let the balloons float away and thereby have one less object to worry about. Naturally, both the cow wallpaper and the balloons (which periodically had to be refilled with helium due to loss of the gas) were hardly conducive to mass sales, and financially the show was not a great success.

The 1966 exhibition marked the end of Warhol's finest period as a visual artist, for between then and the early 1970s the focus of his creative interests moved elsewhere, mainly to film-making.

Walking Torso

1977
synthetic paint and silkscreen, 127 x 101.9 cm
Mugrabi collection

With the exception of the packing carton and *Silver Clouds* sculptures, which obviously related to the anti-art gestures of earlier masters of Dadaism such as Marcel Duchamp, it is possible to divide the majority of works created between 1961 and 1966 into two clear categories. First there are the iconic images. These are the consumer-object works, such as the soup can or Coke bottle pictures and the paintings of movie stars or of 'most wanted men'.

Self-Portrait with a Skull

1978
silkscreen ink, acrylic paint on canvas, 40.6 x 33 cm
Private Collection

155

In such images Warhol was obviously inspired by the way that Jasper Johns had intensified the iconic qualities of the American flag by isolating it frontally and setting it amid a field of flat colour, for Warhol similarly isolated and set his objects or people so as to project them as solitary or multiplicatory icons, albeit icons of American popular culture (into this category the electric chair pictures may also be fitted). Then there are the situation pictures, such as the paint-by-numbers and the deaths and disasters paintings.

Self-Portrait
———————
1978
silkscreen ink, acrylic paint on canvas, 100 x 100 cm
Private Collection

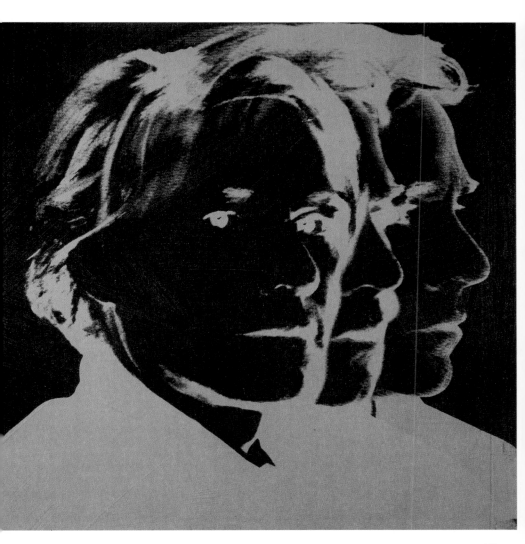

Here the original visual material on which the works were based was less well-disposed to such iconic projection simply because it is more visually asymmetric, and in any case the imagery itself projects dramatic situations, rather than static or passive ones. Of course, in both categories of works the repetition of the imagery carries cultural implications pertaining to mass-communications, as does the mechanical appearance of things, as already discussed.

O.J. Simpson

1978
silkscreen and acrylic paint on canvas, 101.6 x 101.6 cm
Richard Weisman collection, Seattle

And between 1961 and 1966 this imagery had touched upon a vast range of activity and experience: mass-production and commercialisation; money-worship and media-worship; the superficialities of the mass-communications media; criminality, death and disaster (from domestic disasters to atomic annihilation); and the natural world, both as flora and fauna. Warhol's increasing disillusion with fixed images by 1966 was therefore probably inevitable, given that he had used up subject-matter 'so fast that he was feeling exhausted of imagination'. Where could he go next?

A Green Cow

1979
silkscreen and acrylic paint on canvas, 118 x 68.9 cm
Bruno Bischofberger collection, Zurich

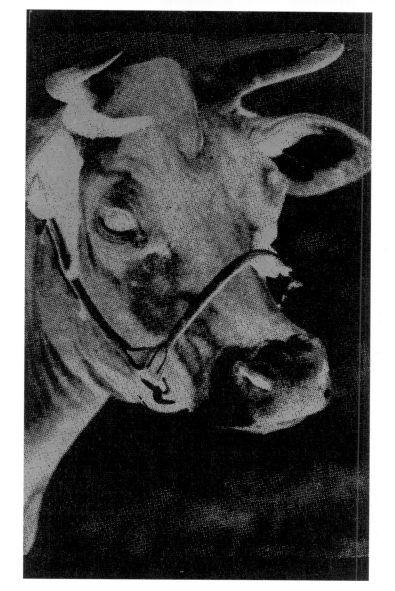

Faced with this exhaustion, Warhol turned to other forms of cultural expression. He took over a rock band, the Velvet Underground, and in April 1966 he made this group, along with the singer Nico, the centrepiece of a multimedia music show entitled the Exploding Plastic Inevitable. He also created his first commercially successful film, *Chelsea Girls*, and here again he made evident his desire to open up new visual experiences, for several reels of the movie were designed to be simultaneously projected on two adjacent screens, each with a different soundtrack.

White Mona Lisa

1979
silkscreen and acrylic paint on canvas, 62.9 x 50.5 cm
Bruno Bischofberger collection, Zurich

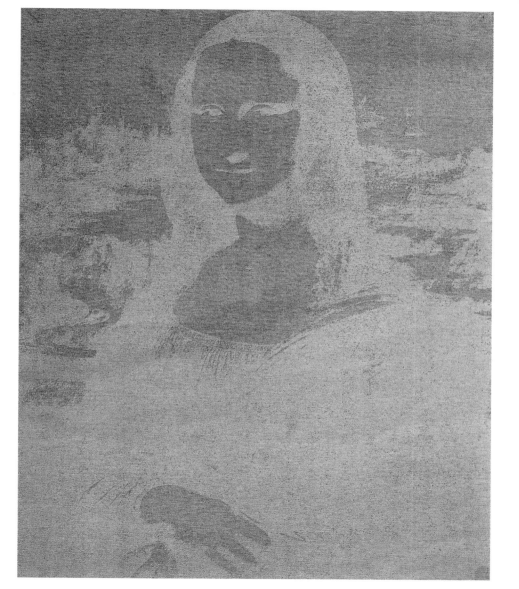

But as far as his fine art activities were involved, by 1967 Warhol's career was further on the wane. Again he sought help from outside, for as Ivan Karp later recalled, Warhol complained that

"Ivan, there's nothing left for me." He said, "I'm a popular character....but I've got no images." I said, "What's left for you? Do yourself."

The result was a group of self-portraits that, intentionally or not, make the point that Warhol had himself become a cultural icon by 1967.

Black on Black Retrospective

1979
synthetic paint and silkscreen, 75.5 x 187.9 cm
Mugrabi collection

This was soon borne out by the fact that the works came to be amongst the painter's most widely publicised images. In 1967, also, Warhol made a further set of Electric Chairs paintings. But perhaps his biggest step forward as a fine artist that year was through his discovery of the creative and commercial potential of large-scale sets of prints. He had earlier made one-off prints but now he created a set of ten silkscreen-on-paper portraits of Marilyn Monroe in an edition of 250 portfolios of the ten prints.

Portrait of Joseph Beuys

1980
synthetic paint with diamond dust and silkscreen on canvas
254 x 203.2 cm
Museum für Gegenwart, Berlin

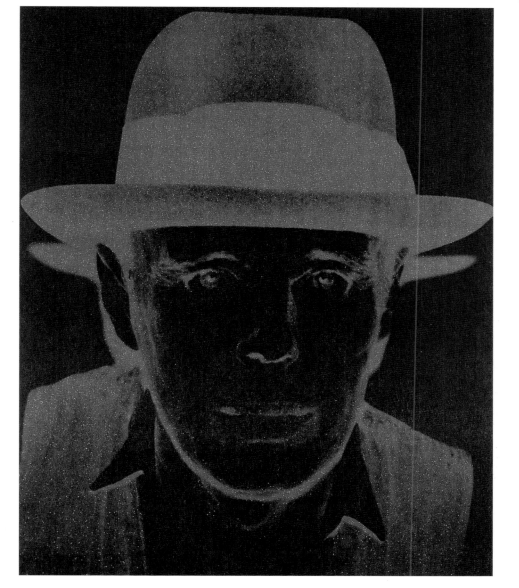

These prints once again demonstrate Warhol's remarkable powers as a colourist and the sets soon sold out, prompting the artist to pursue the creation of many more such portfolios, which henceforth assured Warhol a good income from his work.

By the late 1960s Warhol had surrounded himself with many unstable followers and helpers in his studio, the so-called Factory, located at 33 Union Square West.

Ten Portraits of Jews of the Twentieth Century (The Marx Brothers)

———

1980
acrylic paint and silkscreen on canvas, 101.6 x 101.6 cm
Ronald Feldman fine Arts, New York

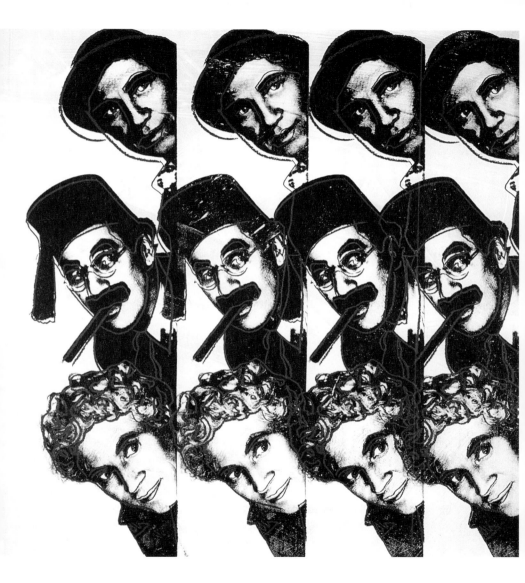

And it was there, on 3 June 1968, that he was shot three times by Valerie Solanas, a mentally-ill actress, feminist and founder of a one-woman Society for Cutting Up Men (SCUM). The third bullet passed right through him, badly injuring his gall bladder, liver, spleen, and other vital organs *en route*. (Subsequently Solanas received a three-year prison sentence for the shooting.)

Diamond Dust Shoes

1980
synthetic paint with diamond dust and silkscreen on canvas
228.6 x 177.8 cm
The Andy Warhol museum, Pittsburgh

Warhol was rushed to hospital where he was immediately operated on, and fortunately the operation was successful, although the painter had to undergo further surgery the following year. Unsurprisingly this failed murder attempt was to take its eventual psychological toll on Warhol by greatly heightening his feeling that both life and art are senseless.

Martha Graham

1980
synthetic paint with diamond dust and silkscreen on canvas
101,6 x 101,6 cm

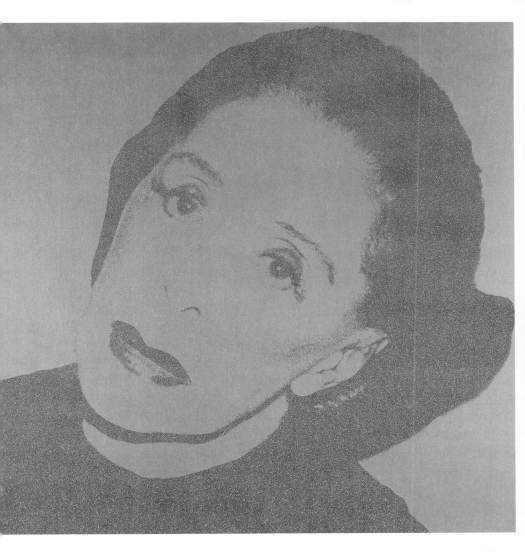

Warhol virtually gave up painting between 1969 and 1971, telling a friend that 'The critics are the real artists, the dealers are the real artists too. I don't paint any more. Painting is dead.' Instead he increased his other activities, in the autumn of 1969 founding an underground movie magazine, *Andy Warhol's Interview*, and also producing his most commercially successful film, *Trash*. But Warhol made a welcome return to the visual arts in the winter of 1971-72 by creating over 2000 paintings of the Chinese communist leader Chairman Mao.

Ten Portraits of Jews of the Twentieth Century (Albert Einstein)

———

1980
silkscreen and acrylic paint on canvas, 101.6 x 101.6 cm
Ronald Feldman fine Arts, New York

It was a masterly piece of irony on his part, for the politician represented everything that is antithetical to the American political, financial and cultural system, whilst the vast proliferation of such images (which were greatly increased in numbers by a Mao wallpaper that Warhol produced to hang as a backdrop for an exhibition he held of the pictures) made highly relevant points about the worship of politicians and the proliferation of idolising images of them.

Diamond Dust Shoes

1980
synthetic paint with diamond dust and silkscreen on canvas
228.6 x 177.8 cm
The Andy Warhol museum, Pittsburgh.

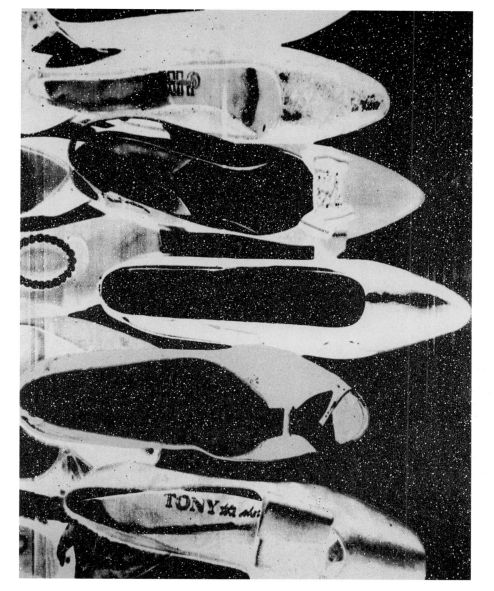

Yet Warhol's true interests did not lie in the political arena; instead, he was much more alert to the glamour of politics, as well as the politics of glamour. By the mid-1970s *Interview* magazine was becoming highly successful as it sloughed off its old identity as a movie magazine and instead covered the unfolding Manhattan social scene. At the time, increasing affluence was taking the social narcissism and moral turpitude of wealthy New Yorkers to new lows, and Warhol was in the vanguard of that hedonistic, mindless sensibility.

Cross

———

ca. 1981-1982
synthetic paint polymer and silkscreen, 228.6 x 177.8 cm
The Andy Warhol museum, Pittsburgh.

The artist frequented the 'in-crowd' discotheque, Studio 54; he cultivated contacts in the pop music world such as Bob Dylan, Mick Jagger and John Lennon; he hung around the White House and hobnobbed with doomed kings and dictators, such as the Shah of Iran and President Marcos of the Phillipines; and money became more and more of a creative incentive to him as his lavish international lifestyle demanded constant refuelling – as he stated in his book *The Philosophy of Andy Warhol*, published in 1975:

Gun

———

1981

silkscreen ink, acrylic paint on canvas, 177.8 x 228.6 cm

Anthony d'Offay Gallery, London

Business art is the step that comes after Art. I started as a commercial artist, and I want to finish as a business artist. After I did the thing called "art" or whatever it's called, I went into business art. I wanted to be an Art Businessman or a Business Artist. Being good in business is the most fascinating kind of art.

To that end Warhol now began making huge numbers of commissioned portraits of the wealthy and famous – all that was required to be painted by him was the $25,000 cover price (and further copies came cheaper, so why not buy a set?).

Myths (Multiple)

1981
synthetic paint polymer and silkscreen, 254 x 254 cm
The Andy Warhol museum, Pittsburgh.

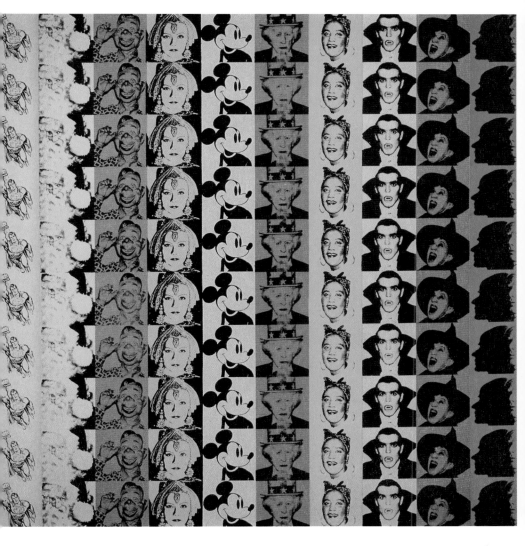

By the mid-1970s such portraits were earning the painter well over a million dollars a year. Henceforth two main tracks would run parallel in Warhol's visual output: his society portraits, which are usually as vapid as his writings on social matters (such as his *Diary*, which must rank highly as one of the fifty most ineffably boring books ever published); and those sadly fewer but by no means negligible numbers of paintings and prints in which Warhol the master explorer of the artistic and social implications of mass-culture still shone forth.

Dollar Sign

———

1981
synthetic paint polymer and silkscreen, 228.6 x 177.8 cm
The Andy Warhol museum, Pittsburgh.

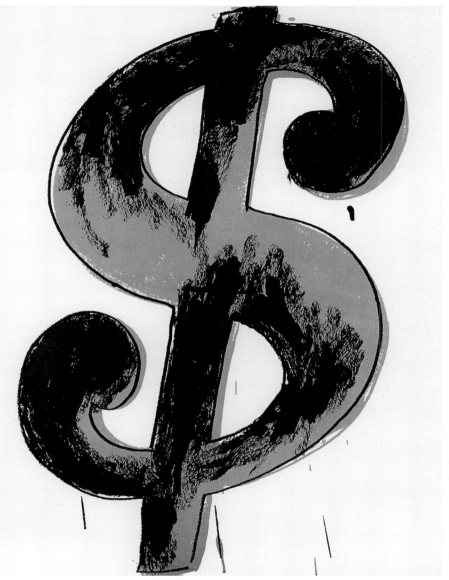

185

In 1975 Warhol made portfolios of Mick Jagger portrait prints and the *Ladies and Gentlemen* series of prints of drag queens, neither of which are of much artistic interest. And in the spring of 1976 he produced a final movie, *Bad*. It was the most expensive of all his cinematic efforts but it did very poorly at the box office, and that failure put an end to Warhol's cinematic career.

Dollar Sign

1981
synthetic paint polymer and silkscreen, 228.6 x 177.8 cm
The Andy Warhol museum, Pittsburgh

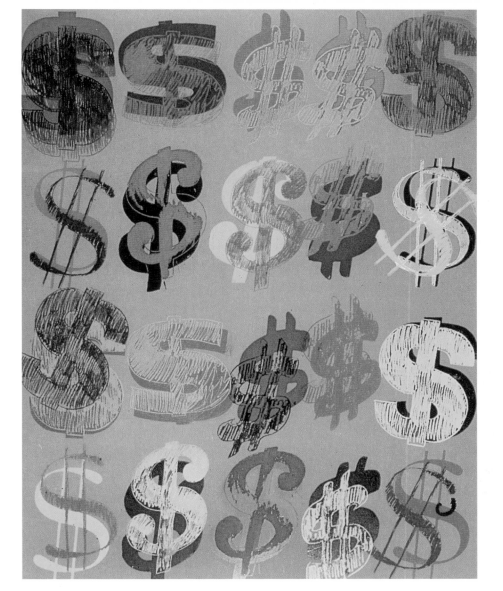

One might bemoan the fact that filmmaking had kept the artist from his canvases for so many years, but given the absence of fresh painterly ideas it is clear that it was a necessary activity for him, and in any case his visual creativity was undoubtedly stimulated by it.

Warhol's major artistic efforts in 1976 were his Hammer and Sickle, and Skulls series of paintings and prints. The Hammer and Sickle images add little if anything to the political and cultural irony of the Chairman Mao series, although they are fairly inventive visually, given the characteristic shapes of the objects they represent.

Myths (Uncle Sam)

1981
acrylic paint on canvas, 152.4 x 152.4 cm
Ronald Feldman fine Arts, New York

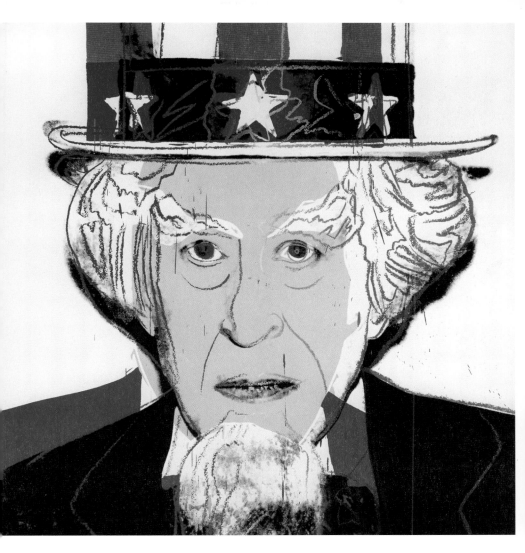

However, the Skulls did mark a notable addition to Warhol's subject-matter, for they not only introduce associations that Warhol found especially pertinent after his shooting in 1968 (although he had dealt with those implications earlier) but also they relate to a long tradition of *Momento mori* images in Western art.

In 1977 Warhol made the Athletes, Torsos and American Indian pictures, as well as his Oxidation series of paintings.

Myths (Mickey Mouse)

1981
synthetic paint polymer and silkscreen, 152.4 x 152.4 cm
Mugrabi collection

The Athletes were an unashamed attempt to make some quick money with which to recoup the losses on the film *Bad*, and comprised portraits of a number of leading sporting figures such as Muhammed Ali, Pelé, Jack Nicklaus and Chris Evert; none of the images are particularly interesting. Nor are the Torsos, a group of studies of both male and female nudes that work at the interface of representation and abstraction but which are not especially stimulating in either mode.

Myths (Dracula)

———————

1981
acrylic paint on canvas, 152.4 x 152.4 cm
Ronald Feldman fine Arts, New York

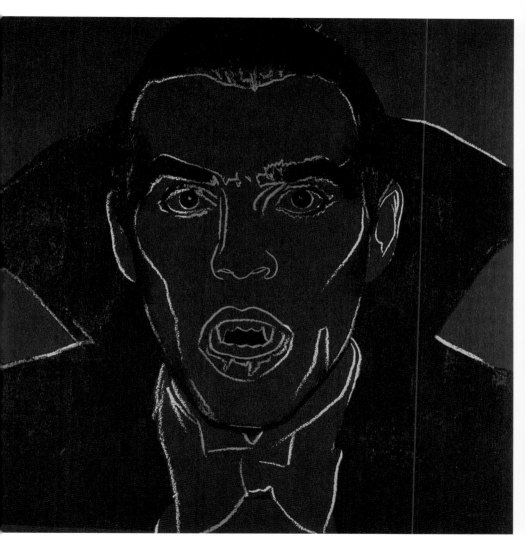

The *American Indian* is simply a portrait of Russell Means who fought for American Indian rights in the 1970s. And the Oxidation paintings perhaps represent the lowest conceptual and visual point that Warhol ever reached in his career, being a rather infantile anti-art gesture, of the type he had already made surreptitiously nearly twenty years earlier.

Giorgio Armani

1981
acrylic paint on canvas, 100.9 x 100.9 cm
Ronald Feldman fine Arts, New York

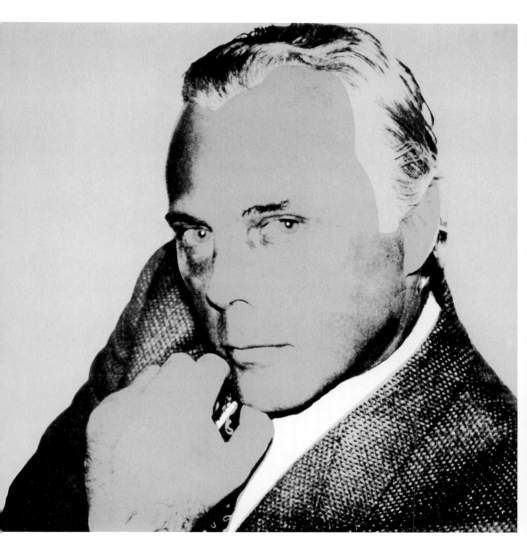

The new pictures were created by coating canvases with copper paint onto which Warhol and his friends then urinated whilst the paint was still wet, so that the chemical interaction of the urine and paint caused the latter to oxidise (naturally, the paintings did not exude particularly pleasant smells either).

Warhol turned to male pornography in 1978 for the subject of his next group of images, the Sex Parts paintings and prints.

Knives

1982
synthetic paint polymer and silkscreen, 180 x 132 cm
Mugrabi collection

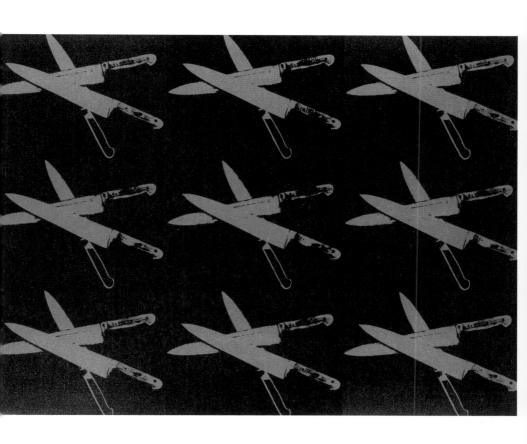

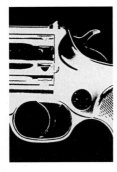

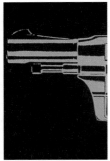

Aesthetically and visually these works differ little from their original source material, the artist's intervention being just a few rather meaningless outlines superimposed over pornographic photo images. Far more challenging was his series of Shadows paintings. With the Oxidations and the Rorschach Test paintings of 1984, as well as a little-known series of explorations of the abstract potentialities of camouflage patterning made in the mid-1980s, these are Warhol's only non-representational pictures.

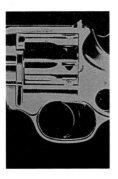

Guns

———

1982
synthetic paint polymer and silkscreen, 132 x 177.8 cm
Mugrabi collection

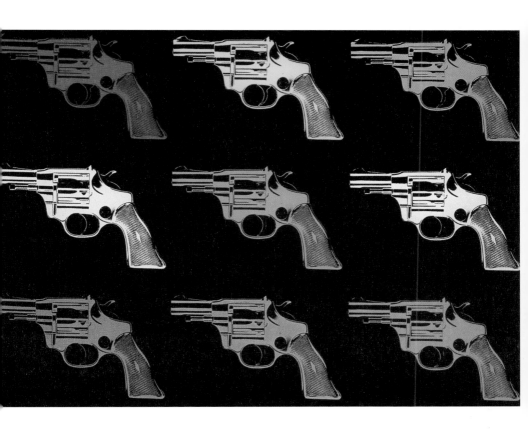

Although they are not particularly interesting individually, being in form superficially reminiscent of works by Franz Kline, when the Shadows are exhibited *en masse* – as they were in New York in 1979 – they certainly make an effective point about the cultural proliferation of abstract art. And there is also a further level to these works which only emerges if we consider them in relation to Warhol's next two series of pictures, the Reversals and the Retrospectives, both begun in 1978.

Seismograph

———————

1982
synthetic paint polymer and silkscreen, 269.2 x 199.3 cm
Mugrabi collection

In both of these series Warhol recycled familiar images, perhaps in the case of the Retrospectives under the influence of Marcel Duchamp who had similarly surveyed his own earlier works in his *La Boite en Valise*, two copies of which Warhol owned. The Reversals simply repeat the images used years before in works such as the Marilyns or the Mona Lisa paintings, except that they are now tonally reversed and look like photographic negatives.

Eggs

———

1982
synthetic paint polymer and silkscreen, 228.6 x 177.8 cm
The Andy Warhol museum, Pittsburgh.

The Retrospectives comprise agglomerations of old Warhol images, either in random arrangements or in vertically-orientated series of visual strips. These latter configurations are identical to photo-booth vertical photographic strips, or perhaps they suggest strips of movie celluloid laid side-by-side. In all of these works Warhol characteristically explored new colour and tonal potentialities.

Zeitgeist: Stadium

ca. 1982
synthetic paint polymer and silkscreen, 228.6 x 177.8 cm
The Andy Warhol museum, Pittsburgh

Yet equally he offered a comment on himself that ties in with his largely nihilistic outlook more generally: the Reversals project a negative view of the painter's own artistic achievements, while the Retrospectives either offer a jumbled view of Warhol's achievements or create associations of memory and processing, as though the art was simply something that had been processed *en masse*, which undoubtedly it had by 1979.

Monument for 16 Soldiers

1982
acrylic paint and silkscreen, 330.2 x 177.8 cm
Bruno Bischofberger collection, Zurich

207

And together these two series afford an additional insight into what Warhol may have been saying indirectly in the Shadows, for shadows are one of the oldest metaphors in existence for the negative and fleeting nature of things. The very negativity and evanescence that lies behind the Reversals and Retrospectives series was surely prefigured in the Shadows series.

Apple in Red

—————

1983
acrylic paint and silkscreen, 35.8 x 27.9 cm
Bruno Bischofberger collection, Zurich

Andy Warhol continued to live in the fast lane during the late 1970s and 1980s. In 1979 he produced his own cable television programme, *Andy Warhol's TV*, and although this was broadcast weekly for about two years (and came back again later) it was commercially unsuccessful, for few people ever showed much interest in the artist's self-indulgent and narcissistic televisual approach to the world. Warhol travelled a great deal, and even made a trip to Iran in 1976;

Panda Toy

1983
acrylic on canvas, 35.5 x 27.9 cm

he published a book of vapid photographs of the international jet-set, *Exposures*, for which he undertook a U.S and European promotional tour; he held a 'Portraits of the Seventies' exhibition of depictions of his jet-set friends and clients at the Whitney Museum in New York at the end of 1979; and he launched into the 1980s by making a series of pictures entitled *Ten Portraits of Jews of the Twentieth Century*, images that include portrayals of Freud, Einstein, Gershwin, Martin Buber and the Marx Brothers but which unfortunately look like record album covers.

Terrier

———

1983
acrylic paint and silkscreen, 35.8 x 27.9 cm
Bruno Bischofberger collection, Zurich

MECHANICAL Terrier

NOT RECOMMENDED FOR CHILDREN UNDER 3 YEARS AGE.

And Warhol hit a new artistic low in November 1981 when he exhibited at the Los Angeles Institute of Contemporary Art alongside LeRoy Neiman, a kitsch, illustrative painter mostly employed by *Playboy* magazine (which underwrote the show). Yet at the same time Warhol painted a series of portraits of the German artist Joseph Beuys which make a very strong and witty cultural comment upon Beuys's status by covering his tonally reversed image with glittering artificial diamond dust, as though to play up the associations of showbiz glitter that Beuys enjoyed in the art world.

Parrot #3

acrylic paint and silkscreen on canvas, 24.9 x 19.9 cm
Bruno Bischofberger collection, Zurich

Warhol's next significant group of works dated from 1981 when he made the Dollar Signs, Knives, Guns and Myths series of paintings and prints. The first set returned to Warhol's favourite theme without adding much conceptually, although the array of $-signs does enjoy a certain visual wit. The Knives and Guns act as passive reminders of the American glamorization of violence, while the Myths series simply points up, yet again, the essential mythicality and cultural centrality of figures such as Mickey Mouse, Superman,

The Moon Explorer # 8

1983
acrylic paint and silkscreen, 24.9 x 19.9 cm
Bruno Bischofberger collection, Zurich

Uncle Sam and even Warhol himself, who doubles in the pictures as a radio star entitled 'The Shadow' he remembered from the 1930s.

In order to make the kind of money that would support his affluent lifestyle, Warhol's portrait industry rolled on in its fairly meaningless way, generating huge profits but rather worthless images. Additions to the oeuvre were the German Monuments series, showing a range of buildings, including ones built by the Nazis; the straightforward Goethe pictures which simply recycle Wilhelm Tischbein's famous portrait of the great poet;

Roli Zoli

———

1983
acrylic paint and silkscreen on canvas, 35.8 x 27.9 cm
Bruno Bischofberger collection, Zurich

and the De Chirico Replicas which repetitively point up the Italian painter's own visual repetitiousness. Further art historical recycling took place in 1984 when Warhol reworked images by Edvard Munch and details from Italian Old Master paintings. Neither series do anything to improve upon their sources. Nor does the Rorschach Test series of paintings, for Warhol invented his own abstract patterns, unaware that the Swiss psychiatrist, Hermann Rorschach, had made uniform sets of such psychological testing patterns so as to be able to gauge responses uniformly.

Panda Bear
————

1983
acrylic paint and silkscreen on canvas, 24.9 x 19.9 cm
Bruno Bischofberger collection, Zurich

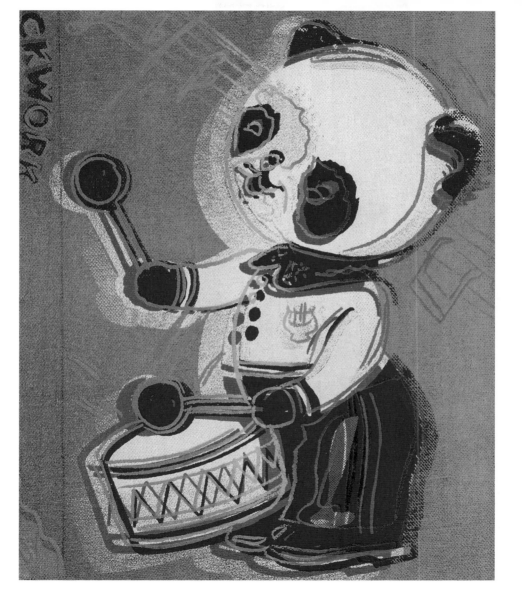

And a further sign of Warhol's loss of daring and imagination by 1984 came in his short-lived artistic collaboration with two much younger but up-and-coming stars of the New York art scene, Francesco Clemente and Jean-Michel Basquiat. Both these artists rose to fame as a result of the 'post-modernist' exploration of graffiti and infantile imagery, and the works that Warhol made in collaboration with them seem a sloppy mishmash of styles, without any visual point or conviction.

Rorschach
——————

1984
synthetic paint polymer and silkscreen, 304.8 x 243.8 cm
Gagosian gallery, New York

Here life imitated art in its disconnection, for by the time Warhol and Basquiat exhibited the fruits of their collaboration in New York in September 1985, neither artist was on speaking terms with the other.

The quality of Warhol's art had become even worse by then, as he turned out an Advertisements series of paintings and prints in which he simply recycled ads for diverse products such as Chanel No.5 perfume and the Volkswagen Beetle, while attempts to add a little wit to the series by reproducing a Chinese design featuring James Dean or one of Ronald Reagan's old shirt adverts fell rather flat in the

Rorschach

———

1984
synthetic paint polymer and silkscreen, 279.4 x 254 cm
Gagosian gallery, New York

face of the evident prostitution of Warhol's talent: 'Business Art' it may have been, but it is a bad businessman who brazenly adulterates the quality of his own products. A series of Queens, this time not gay queens but female monarchs of England, Denmark, Holland and Swaziland, was made entirely by studio assistants following Warhol's instructions, although ultimately the artist himself must bear full responsibility for creating such dull images.

Jean-Michel Basquiat

ca. 1984
synthetic paint polymer and silkscreen, 101.6 x 101.6 cm
The Andy Warhol museum, Pittsburgh.

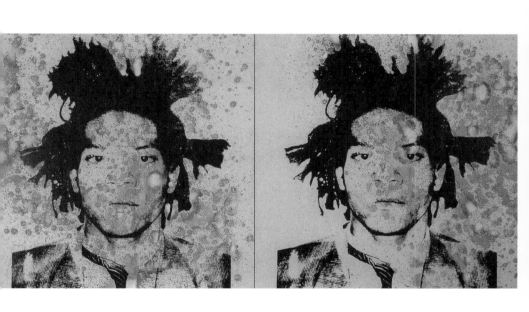

In 1986 Warhol made new but tired images of Lenin and of Frederick the Great; the former series covered exactly the same ironic ground as the Chairman Mao pictures, while the portrayals of Frederick the Great were commercially aimed at the highly lucrative German market, and say nothing about the great Prussian, either ironically or otherwise.

Andy Warhol and Jean-Michel Basquiat: Monster Meat

1984-1985
synthetic paint polymer and silkscreen, 261.6 x 260.4 cm
Gagosian gallery, New York

Yet in 1986 there was also a return to form, for in his *Last Supper* paintings Warhol did have something to say about the way that great religious art can be turned into cultural kitsch, whilst through using army camouflage patternings in several last self-portraits and other works (including a number of the *Last Supper* paintings), he found a way of creating interesting visual maskings that again project negation.

Reigning Queens
Queen Elizabeth II

1985
silkscreen on paper, 100 x 79.5 cm
The Tate gallery, London

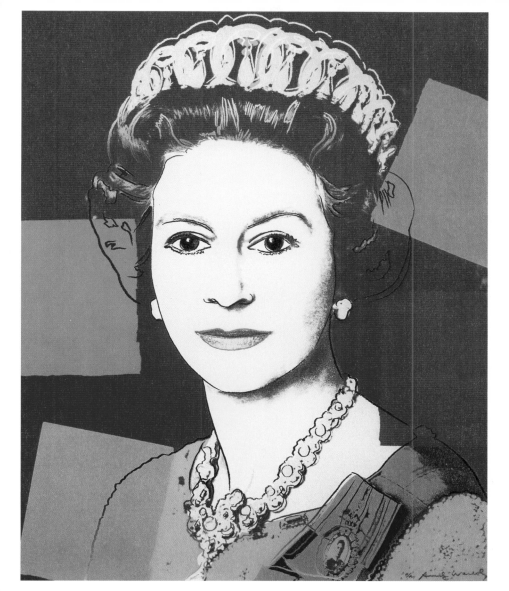

And in a final series of images, the sewn photographs of 1986-87, Warhol once again employed repetition and tonality both to make familiar points about cultural repetition and to move recognisable imagery closer to abstraction. This had always been a positive quality of his art, ever since he had first became aware that repetition brings out the inherent abstraction of things.

Reigning Queens
Ntombi Twala of Swaziland

1985
synthetic paint polymer and silkscreen, 127 x 106.7 cm
Cardi & Co., Milan

Warhol then created images of Redo Watches and of Ludwig van Beethoven, whilst planning the creation of yet another grandiose series of pictures, this time relating to the history of American television. But it was not to be. On 20 February 1987 Warhol checked into New York Hospital for a routine gallbladder operation the following day. Although the operation itself was successful, the post-operative care was very poor and early the next morning the painter died. He was just fifty-nine years old.

Dolly Parton

1985
synthetic paint polymer and silkscreen on canvas, 2 works,
106.7 x 106.7 cm each
The Andy Warhol museum, Pittsburgh.

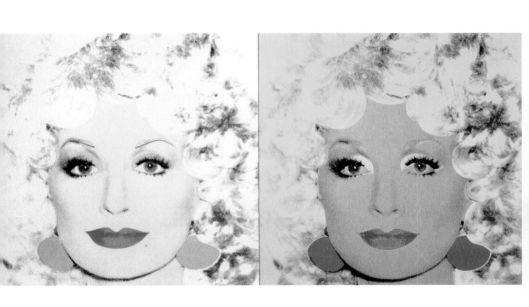

His body was taken back to Pittsburgh for burial; his tombstone was marked simply with his name and dates, even though he had once requested that it should either be left blank or alternatively bear just the word 'figment'. The major part of his estate, valued at between $75 million and $100 million, went to create an arts charity, the Andy Warhol Foundation for the Visual Arts, which is now one of the richest such organisations ever established in the United States.

Andy Warhol
Jean-Michel Basquiat, New Flame

1985
acrylic paint on canvas
200 x 264 cm Bruno Bischofberger collection, Zürich

By the end of his life Andy Warhol had become one of the leading mass-media personalities of his day and a touchstone of superficial contemporary social mores. But this should not blind us to his earlier seriousness and creative achievements. Certainly his career as a fine artist after the mid-1960s was uneven, but that seems inevitable, for between 1961 and 1966 the painter had explored most major aspects of modern experience and consequently had not left himself much else to add.

Andy Warhol
Jean-Michel Basquiat Stoves

1985
acrylic paint on canvas, 203.2 x 274 cm
Bruno Bischofberger collection, Zürich

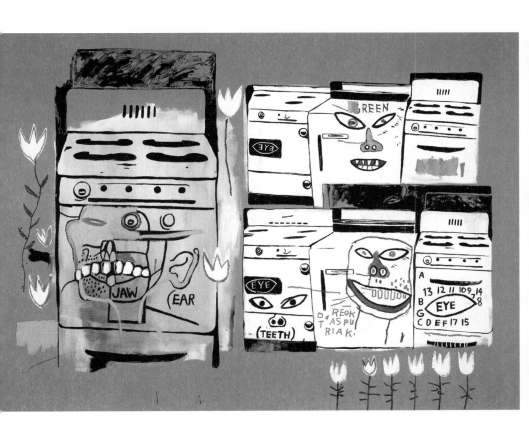

After that time he painted more uncertainly and unevenly, although occasionally he articulated something of importance, as with the Chairman Mao images of 1972 or the Reversals pictures of around 1980. And after 1968 Warhol seems understandably to have felt that he was living on borrowed time, so the nihilism and resulting shallowness of his latter days are surely explained by that realisation.

Self-Portrait

1986
silkscreen and acrylic paint on canvas, 101.6 x 101.6 cm
Private Collection

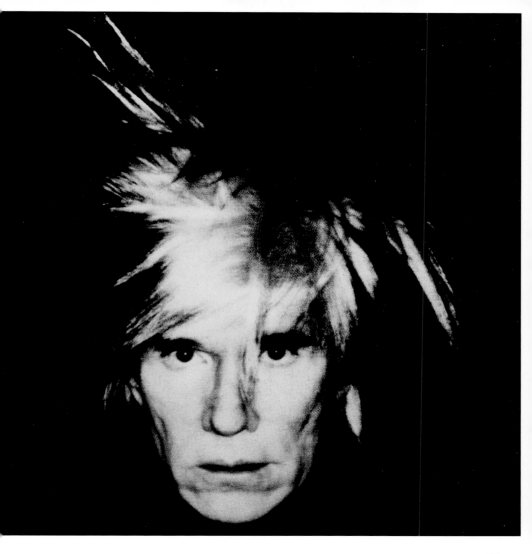

Yet despite all his apparent cynicism and his outward refusals to seem serious, Andy Warhol was far more than just a superficial Pop artist, for unlike many of his creative contemporaries his finest work is not simply about having fun in a mass-culture: it confronts us with some of the underlying and most uncomfortable truths of our age, such as the inhumanity, exploitativeness, banality, trivialisation and destructiveness of modern culture, as well as our loss of faith in God, art and life itself.

The Last Supper

1986
synthetic paint polymer and silkscreen, 101.6 x 101.6 cm
The Andy Warhol museum, Pittsburgh.

243

Warhol may have wanted to appear to be a machine but under his apparent and assumed *sang-froid*, pretended intellectual vacancy and desire for fame there lay an artist who did experience the pain of things considerably and expressed it subtly and cleverly in much of his work. (Indeed, the false imperturbability and mindlessness, and the pursuit of fame were all evidently ways of staving off that pain.)

The Last Supper

1986
synthetic paint polymer and silkscreen, 198.1 x 777.2 cm
The Andy Warhol museum, Pittsburgh

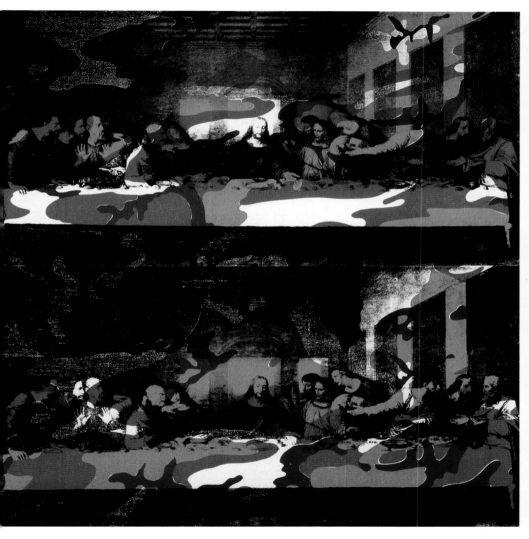

Pain is expressible not only in tortured mouthings; it can be articulated by a detached voice, or even a hollow one. In Warhol's pictures of the material objects and other false idols that most of us worship, the pain lies just below the bright surfaces of the images and waits passively to engage us. If and when we take it seriously, the art of Andy Warhol has much to warn us about the perils that confront us as we now move into a increasingly manipulative and teeming new millenium.

Camouflage

———————

1986
synthetic paint polymer and silkscreen, 203.2 x 203.2 cm
Gagosian gallery, New York.

Index